CHARLESTON CURIOSITIES

STORIES OF THE

TRAGIC HEROIC AND BIZARRE

MICHAEL COKER

THE
History
PRESS

Published by The History Press
Charleston, SC 29403
www.historypress.net

Copyright © 2008 by Michael Coker
All rights reserved

Cover design by Marshall Hudson

Front cover images, clockwise from top left: appeal of the enslaved, author's collection; Sergeant Jasper raising the flag at Fort Moultrie, courtesy of the Library of Congress; circa 1851 view of Charleston by William Hill, Archive.org; eighteenth-century Native American warrior, author's collection.
Back cover images, left to right: Osceola, courtesy of the Library of Congress; John C. Calhoun, courtesy of the Library of Congress.

First published 2008
Second printing 2010
Third printing 2010
Fourth printing 2011
Fifth printing 2012
Sixth printing 2013

Manufactured in the United States

ISBN 978.1.59629.511.7

Library of Congress Cataloging-in-Publication Data

Coker, Mike.
Charleston curiosities : stories of the tragic, heroic, and bizarre / Michael Coker.
p. cm.
Includes bibliographical references.
ISBN 978-1-59629-511-7
1. Charleston (S.C.)--History--Anecdotes. 2. Charleston (S.C.)--Biography--Anecdotes. 3. Charleston (S.C.)--History--Pictorial works. 4. Curiosities and wonders--South Carolina--Charleston--Anecdotes. I. Title.
F279.C457C65 2008
975.7'915--dc22
2008024008

CONTENTS

INTRODUCTION

Charleston's history is so rich and varied that this small collection only just barely scratches the surface. I do not intend this book to be an encompassing guide to the Holy City's past; I would need several more volumes and thousands more pages in which to do that topic any sort of justice. Rather, I selected these particular pieces because they run the gamut from the early colonial to the twentieth century. You will find biographical sketches and vignettes that are tragic, heroic or just plain bizarre. In other words, curiosities.

Some of the chapters, such as the 1706 invasion and the Battle of Secessionville, obviously belong in a collection about Charleston. Others may seem out of place at first glance. I included the chapter on the Battle of Honey Hill because, like the Battle of Secessionville, Charleston's ultimate fate was tied to the nearby conflict. The British sortie out of Charles Town in 1781, which resulted in the Battle of Parker's Ferry in Colleton County, weakened the king's hold in the area, especially in Charles Town. The Stono rebellion caused great alarm and consternation in Charles Town, as the city was flooded with refugees for weeks while the rebels were hunted down.

A few words about my choice of words within the text, which I hope will not be confusing. The terms Federal and Union are used interchangeably when referring to soldiers fighting under President

Lincoln's government. In the American Revolution, both sides referred to themselves as "Patriots." For the sake of simplicity, I refer to those who fought against British rule as "Patriots" and those who wanted the king's rule reinstated as "British," when in fact a large number were actually born in the colonies or were of other nationalities. At the Battle of Parker's Ferry (chapter 6) there were Hessian, or German, troops facing Marion's men. "Charles Town" did not become "Charleston" until 1783, and I have tried to keep the timeline as straight as possible, but this is difficult as some of the direct quotes in the text use the later designation of Charleston when describing a period when it was still actively called Charles Town.

The style of this book is fairly informal, with a focus on the narrative rather than the academic. Ira Glass, and his program *This American Life*, has been my constant role model while putting this manuscript together, along with the pioneering narrative works of Erik Larson, Bruce Catton and Shelby Foote. In an attempt to keep the text fast moving and engaging, I do occasionally dabble in the speculative. Hopefully I do not cross the line into historical fiction with my theories and assumptions or alter the facts in the process. My apologies to the authors whose writing and research I have synthesized into my text. Were this book another format, it would be loaded with citations. In the selected bibliography I have tried to include the works that influenced me the most or ones that I drew upon frequently. Patrick O' Kelly's exhaustive work on the Breach Inlet battle was invaluable, as were Dr. Mark Smith's research on the Stono rebellion and Patricia Wickman's study of Osceola. I always thought people who said, "I stood on the shoulders of giants" were guilty of false modesty. Now I know there is truth in that statement.

Many of these pieces have been published before in local newspapers, the South Carolina Historical Society membership magazine (*Carologue*) and *charleston* magazine. To Faye Jensen, John Tucker, Jane Aldrich (whose comments on the Stono piece were much appreciated), Katherine Giles, Mary Jo Fairchild and the rest of the SCHS staff, my sincere heartfelt thanks. I also wish to

thank Pete Rerig, Darcy Shankland and Melinda Monks at *charleston* magazine for giving a warm reception the first time around to a good number of these pieces. Many others are also due consideration. Shawn Halifax at Charleston County Parks and Recreation (CCPRC) provided comments on the Stono piece and gladly paved the way for me to use the interpretive images of that rebellion by the talented CCPRC artist Beth Burkett. Fellow author Danny Crooks provided suggestions, morale, support and camaraderie.

I am extremely grateful to Laura All, Magan Lyons and the rest of The History Press staff for all of their hard work and answering my many e-mails, dealing with image changes and author delays. Special credit to Hilary McCullough, who edured many long hours on my behalf, refining my raw efforts into a readable and visually stunning book.

A big thanks to Dr. Walter Edgar, not only for his seminal book *The South Carolina Encyclopedia* and his always entertaining NPR show, but also for showing a novice how to keep history engaging and relevant. Dr. Eric Emerson deserves special notice for serving as a mentor; I feel fortunate to have learned from such an accomplished historian. Another friend and first-rate historian who helped me along the way is Dr. Nic Butler at the Charleston County Library. Nic continues to share information about colonial Charles Town and the walled city and always cheerfully answers my many questions. I cannot forget to thank Carol Cumming, my high school English teacher, who continues to guide a new generation of writers with their own voices.

A special thanks to Tony Youmans and the staff at the Old Exchange and Provost Dungeon for their help in photographing the Spanish invader's vest. Thanks to Mary W. Grimball, president and CEO of the Junior Achievement of Central South Carolina, Inc., for graciously allowing use of their stunning image of Elizabeth Timothy.

I owe a debt to Matthew Ducker, a fine writer and superb editor, for reading over this manuscript and making several valuable corrections. His lovely wife Marissa also aided in this long, tedious process.

My family has been a bastion of support. Thanks to my daughter Jacqui Ducker, my mother-in-law Jamie George, mother Susie Wise and brother Chris Coker.

I would like to humbly dedicate this book to my wife, Sheri Ducker. She has given a great measure of herself to help her husband with his publication endeavors, particularly this one. Time after time she took care of the house, ran errands, cooked, cleaned and did virtually everything that needed to be done while holding down a full-time job of her own and attending master's level courses at the College of Charleston so I could write. She also supplied an unbelievable level of support during the whole process. Thank you so much for everything. All of my love.

Visit Charlestoncuriosities.com for more information.

THE INVASION OF CHARLES TOWN, 1706

The following is a speech given by the author to the Charleston Library Society, September 20, 2007:

What if George Washington had drowned while crossing the Delaware?

What if General Lee had won at Gettysburg?

What if John Wilkes Booth's gun had misfired that night in Ford's Theatre?

What if the decision had been made not to drop the bombs on Nagasaki and Hiroshima?

These are just a few examples of turning points. The past is full of them. Open a history book, flip through it with your eyes closed and pick a page at random. When you open your eyes and look, I guarantee that somewhere on that page will be described an event that, had fate been nudged even the slightest degree in another direction, the world as we now know it would not exist; all of the textbooks would have to be rewritten.

I would like to highlight another turning point, one that is seldom given its due. It took place right here in Charleston, or Charles Town, as it was called in 1706. In that year a squadron of warships filled with soldiers and mercenaries, sailing under the flags of France and Spain, came calling at Charles Town. These invaders planned to force the English, whom they viewed as unlawful squatters, out

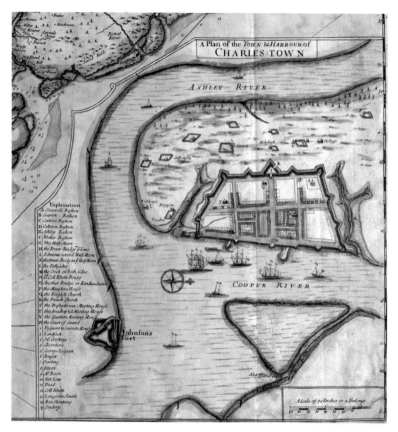

Crisp map of Charles Town, circa 1704–15. *Courtesy of Library of Congress.*

from their walled city and then out of South Carolina altogether. The next part of the campaign was a march into North Carolina, and then into Virginia. From there they could negotiate a surrender of New England. The first vital link in the chain of these military conquests was Charles Town.

The odds were stacked against Charles Town's survival. Political infighting continued to polarize entire segments of the city's small population against one other, which hampered growth and cooperation. The city was also in a deep financial crisis. A failed military expedition of four years earlier continued to drain the coffers. A yellow fever epidemic had recently swept through the city,

killing an estimated 5 percent of the population. Such a weakened place was ready to fall.

What happened? After all, the city is still Charleston, and we are not conversing in French or Spanish. How did we survive? Unfortunately, most histories, even those that focus on South Carolina's colonial period, often sum up the events surrounding the 1706 invasion in a few sentences. Let's take a closer look.

It was Wednesday, August 21, in the year of our Lord 1706, on the deck of a ship called the *Flying Horse*. The *Flying Horse* was a sloop, a small ship of about forty tons crewed by eighty men. There is some evidence that the ship was christened under a different name in the Caribbean over twenty years earlier, and was once a merchant ship. Captain Peter Stoel, a Dutchman, was in command, but he likely had several other silent partners who had invested in the activities of the ship.

The *Flying Horse* was lately out of New York Harbor and was sailing its way down the coast. Just a few days earlier, the ship had visited Charles Town. In that city Captain Stoel made sure his crew had taken on enough food and water and performed all the necessary repairs to their vessel. Although this would be the last friendly port before reaching their objective, Captain Stoel likely did not allow his crew much of a layover. Likely, he monitored his crew very carefully and made this trip as short as possible. Charles Town had just come out of a yellow fever epidemic, and the last thing Captain Stoel wanted brought aboard his ship was that dangerous contagion.

A contemporary account stated that "it pleased God to visit us with a grievous pestilence, which raged chiefly in Charles Town, and began to spread throughout the province." In a population that contained roughly 4,000 white settlers and several thousand enslaved Africans, a 5 percent death toll meant an estimated 250 to 300 deaths, or about 4 to 5 deaths a day during the sickly season.

As soon as possible, Captain Stoel and his crew were back on the ocean, pointed south into hostile waters near the Spanish city of St. Augustine, Florida. Even in times of peace, unpredictable

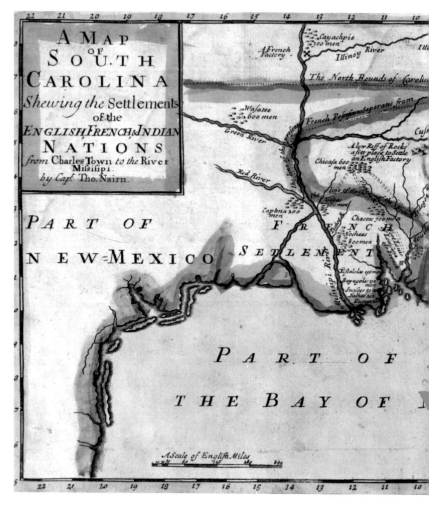

Early colonial map showing North Carolina, South Carolina, Georgia and Florida. *Courtesy of Library of Congress.*

weather, pirates or unsanitary shipboard conditions could make such a voyage hazardous. But sailors in 1706 had something else to add to that list—enemy ships. For upward of four years, war had engulfed much of Europe. Of course, it had long since spilled over into the colonies. Overseas, this conflict was known as the War of the Spanish Succession, while in the New World it was referred to as

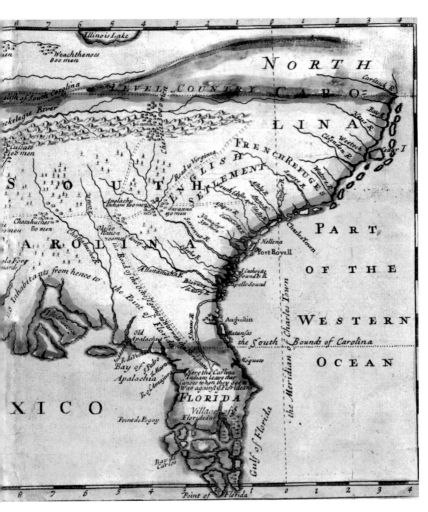

Queen Anne's War. Essentially this war was sparked over who was to sit on the throne of Spain after the death of Charles II.

Spain and France were on one side, and allied against them were Queen Anne's British kingdom with a host of other nations, including Portugal and the Dutch Republic. The *Flying Horse* was in the service of Queen Anne, and as such was warmly received at

English ports, such as Charles Town, along the way. However, it is not just patriotism that motivated Captain Stoel and crew.

A piece of paper called a "letter of marque" was all that separated the *Flying Horse* from being classified as a pirate ship. This was essentially an official sanction to wage war on the vessels of the enemy. This practice was common, and was performed by all the warring parties to augment their navies. In exchange for this license, the Crown asked for a cut of all such plunder.

Captain Stoel's plan was to intercept a Spanish vessel headed to St. Augustine with valuable cargo. As there was no mint in St. Augustine, all coins to pay the soldiers and government officials must have come from elsewhere, most likely Havana in Cuba. It was Stoel's hope that his crew could catch this vessel alone without any escorts, board it, loot it, line their pockets and perhaps even aid the war effort.

Luck was not with Captain Stoel. When the *Flying Horse* approached the bar of St. Augustine, five large ships and a smaller sixth ship were spotted weighing anchor in the harbor. Five were flying French colors, and from the mast of the sixth flew the flag of Spain.

What Captain Stoel said when he discovered his misfortunate is not noted, but the type of language he used can probably safely be guessed at. This was a complete surprise for him; none of the intelligence he had picked up during his cruise had hinted at such a gathering. If there had been even the rumor that this squadron had been assembling in Florida, Captain Stoel would have probably chosen an easier target.

Any one of those ships was a match for the *Flying Horse* and could possibly capture or send Stoel's ship to the bottom. To risk facing five was suicide. He barked out orders to his crew, likely very loudly and excitedly. Their new plan was the better part of valor: turn the *Flying Horse* around, run and survive to privateer another day.

The five enemy ships spotted the *Flying Horse* as well and recognized it as an enemy privateer, and all of them pulled up their anchors in pursuit. A Spanish ship and four French ships started the chase. We know the names of only two of these vessels:

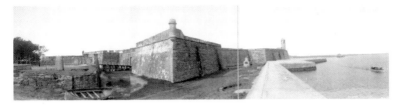

Twentieth-century image of the Spanish fortress Castillo de San Marcos. A similar intimidating fortress protected that port in 1706. *Courtesy of Library of Congress.*

the flagship the *Sun* and the ship that was the last one to join the pursuit, the *Brillante*.

Captain Stoel didn't know it at the time, but what he had stumbled upon was the start of the invasion. By an incredible twist of fate, Captain Stoel had arrived shortly after the French. They had just begun to parlay with their Spanish allies and had taken aboard some soldiers and Indians from St. Augustine when the *Flying Horse* made its appearance.

We will return to Captain Stoel's perilous situation in a moment, but first it is necessary to ask, how did it come to this? Why did the French and Spanish consider the English in Charles Town their enemies? I've already mentioned Queen Anne's War. To be sure, the colonies followed the lead of their mother countries, but they also had much more local and personal reasons for the invasion. An entire lecture series could be given on the colonial-era feuds between Spain, France and England, but as we are focused just on the year 1706, I will be forced to briefly summarize the events that led up to this, each of them a turning point in its own right, I might add.

I used the phrase "unlawful squatters" earlier. What I meant by this was that Spain still thought of South Carolina as its own property. It based this claim on the explorations of numerous explorers and prior settlements. Beginning in 1526, Spain tried to establish a series of forts and towns within the boundaries of South Carolina. A brutal raid on St. Augustine in 1586 by Sir Francis Drake convinced the Spanish to consolidate their power in Florida,

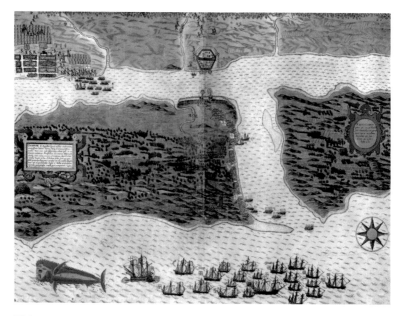

This 1589 map depicts the English privateer Sir Francis Drake's attack on the Spanish city of St. Augustine in Florida. *Courtesy of Library of Congress.*

and no further forays into South Carolina were made until the English arrived.

The eight Lords Proprietors completely disregarded the Spanish and financed a colony to set up right in the heart of their territory. We all know the story of that settlement, started in April of 1670, which is now commemorated by the state park of Charles Towne Landing. In August of that year the Spanish launched an attack to chase out these new settlers, but it did not proceed very far. Ten years after trying to scratch out an existence in the West Ashley area, the colony officially transferred to the peninsula. Part of the reason for this move was a better defensive position against foreign excursion.

In 1684, a group of Scots established Stuart Town near present-day Beaufort. This settlement survived less than two years before the Spanish and their Native American allies marched from St. Augustine and destroyed it. (I understand the

seal of this short lived settlement is housed here at the Library Society.) This Spanish-Indian force planned to continue on its way to Charles Town, but a hurricane hit, and weather turned this invasion back.

In 1702, Charles Town mounted its own offensive. Governor James Moore attacked St. Augustine and burned it to the ground, but was unable to dislodge the defenders from the Castillo de San Marcos. In 1704, a second expedition, once again headed by Moore, left Charles Town and hit the area of West Florida known as the Aplachee, destroying numerous Spanish missions and bringing back hundreds of Indian slaves. So you see, the pattern of attack and retribution had already been long established between the Spanish and the English.

What about the French? What did they have to gain? Their ventures into South Carolina were nowhere near as involved as those of the Spanish. In 1562, Charles Fort, a Huguenot community, was established by Jean Ribault on Parris Island. This was a miserable failure and was abandoned after a year.

In 1699, French colonists settled on the lower Mississippi, near present-day Biloxi, and by 1702 they had moved into the Mobile area. They planned for this to be part of a new trading center. The French were worried that their Spanish allies would fold, St. Augustine would be captured and the English would turn their sights on them. In 1702, a proposal was drafted on how to remove the English from the equation. Essentially, in exchange for Pensacola, the French would help the Spanish deal with the English. In 1705, a version of this plan was approved by the king of France, and the wheels started to turn.

Five ships and some men were procured, and the French docked in Havana to find more volunteers for the invasion. The Spanish officials had not been apprised of this expedition and were hesitant to lend much in the way of material aid. The last stop for the invaders was St. Augustine, where they found a better reception. They had just taken aboard a small complement of Spanish auxiliaries and been joined by another vessel when the privateer was spotted.

Anxious that their existence be kept a secret, they decided to pursue Captain Stoel at all costs before the alarm could be sounded. The *Flying Horse*'s speed and maneuverability served it well. The chase went through the rest of daylight and into the evening. When it became too dark to continue the hunt, the ships all dropped anchor where they were. The *Brillante* noticed that it had been separated from the squadron in the chase and was now all alone. A lantern was lit and hung from the mast as a beacon to the other French and Spanish ships.

Captain Stoel probably ordered all of the lights aboard the *Flying Horse* extinguished and limited the movement on deck to a bare minimum. What a tense night that must have been for the crew of the *Flying Horse*. Here they were deep in enemy territory and hopelessly outnumbered. Out in the darkness, a lantern light marked the presence of one their pursuers, a constant reminder that there were four more out there waiting for them. I imagine neither captain nor crew slept well that night.

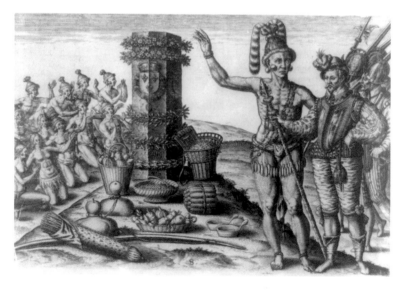

Jean Ribault's short-lived French settlement in South Carolina was called Charlesfort, circa 1562. *Courtesy of Library of Congress.*

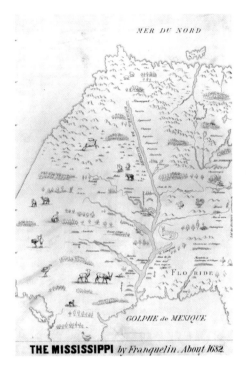

MER DU NORD

FLORIDE

GOLPHE de MEXIQUE

THE MISSISSIPPI *by Franquelin. About 1682.*

This 1682 map shows French ambitions on the lower Mississippi. By 1699, French colonists were in present-day Biloxi, and in the Mobile area by 1702. Prior colonization attempts and fear that their Spanish allies would evacuate Florida, leaving them to face the English, precipitated their involvement in the 1706 attack. *Courtesy of Library of Congress.*

In the morning, the other ships of the squadron reassembled. Nowhere in sight was their prey, nor the *Brillante*. A council of war was held between the remaining ships, and it was decided that the *Brillante* must have made a forced sail in order to capture the privateer. As now time was of the essence, they decided to sail onward to Charles Town. The absence of the *Brillante* would be keenly felt in the days ahead.

As dawn broke, the sailor up in the crow's-nest aboard the *Brillante* strained his eyes as he scanned the horizon. Gradually, another ship just astern of his came into view. It was not one of the squadron, but the privateer. The crew was immediately roused to renew the hunt. Manuel Hernandez, a Spanish freebooter who had joined in Havana, recalled that he and many others aboard asked for weapons in expectation of the coming fight. There were no spare arms to be found, so all those without weapons were shuttled below deck.

The watch aboard the *Flying Horse* must have related the sparseness of the *Brillante*'s deck to Captain Stoel. Not knowing that a trick had been pulled, they turned to engage, the *Flying Horse* aiming its bowsprit (the pole extending forward from the vessel's prow) close to the *Brillante*.

The captain of the *Brillante* must have sensed that he was in real danger. The privateer was bearing down on him, and the greater part of his crew was unarmed. In an effort to bluff Captain Stoel, the *Brillante*'s captain gave the order for the defenseless men below deck to come topside immediately, perhaps hoping that their rush of numbers would dissuade an attack.

It didn't work. The *Flying Horse* was determined to fight. The *Brillante* obliged. The *Flying Horse* had seven cannons and a smaller pivot gun on the deck, and the *Brillante* had six guns of its own. How many of these guns were used in this exchange is unknown; my guess is each ship brought as much firepower as possible to bear on the other ship.

There was a series of sharp cracks as the guns were emptied. Aboard the *Brillante*, the shots plowed through the ranks of the unarmed men. One unfortunate was killed outright, and another three or four were wounded either by concussion, shards of shrapnel or splinters from the chewed-up wooden planking. The *Flying Horse* got the worst of it, however: two of Stoel's sailors were killed and another five wounded.

Rather than take any other offensive actions, the ships kept sailing away from one another, trailing thick clouds of pungent bluish gun smoke as they passed. The *Brillante* turned away from the privateer to seek the safety of the lost squadron. The *Flying Horse* went for the safety of Charles Town. Captain Stoel knew that he must get back into that harbor not only to save his own skin, but also to warn the citizens there that they were about to be attacked.

The *Flying Horse* was successfully navigated back to Charles Town on Saturday, August 24. The *Brillante* was not as fortunate. It became lost along the South Carolina coast, and would reappear only at the very end of the 1706 invasion (more on this later).

The first to note the return of the *Flying Horse* was the watch. Very early in Charles Town's existence a watch house had been established out on the point of Sullivan's Island. The exact site isn't known, but it was likely situated in a place where its sentries could monitor the Atlantic approaches to Charles Town. Also operating out of this area were the pilots. Anyone entering the harbor, especially for the first time, needed guidance on how to navigate a treacherous bar.

It is very likely the same men who admitted the *Flying Horse* into Charles Town the first time were still at their post. What happened next is best summed up by a contemporary account:

> *On Saturday Aug 24, Captain Stoel returned to this port who informed us that the Wednesday before he had engaged a French ship off Augustine Barr…and that the day before he was chased by ships on this coast. He had not been arrived scarce above one hour and not done relating this news before we discovered five smokes on Sullivan's Island which signified that so many vessels were by that look out seen at sea.*

Another account gives us the actions of the then acting commander in chief of Charles Town:

> *Lt. Colonel William Rhett being then in town about four or five of the clock at night he caused an alarm to be made and dispatched away a messenger with a letter to the Governor… and other messengers with letters to the several captains of the companies in the county to order them to make ye alarm and to march forth with their companies to town and at evening he caused the alarm guns at town to be fired.*

As the *Flying Horse* entered the harbor and found a spot to anchor, the church bells began to ring, and cannons mounted along the walled city barked a summons to all those within earshot to come to the city's defense immediately. The sailors aboard the *Flying Horse* had arrived safely, but they had exchanged the mobility of open water for the security of a city weak from

Colonel William Rhett (1666–1721). *Author's collection.*

fever. Many onboard probably wondered if they had made the right choice.

Late into the night, Charles Town did everything it could to rally its forces. Out in the harbor, the French and Spanish sounded the bar, charting the depth of the water, looking for a place to make a safe passage without getting grounded. Even if a safe route had been discovered that night it is unlikely that it would have been taken. They were also waiting for the *Brillante* to arrive, the ship that carried the best troops, the campaign guns, shovels, shells and the land commander for this expedition.

At this point the invasion of Charles Town truly began. Due to constraints of time, I cannot go into the level of detail I would like on each day of this affair, but I will try to give a concise account summary of the important events and parties involved.

Sunday, August 25
The Sullivan's Island watch reported that the enemy was southward of the bar, using some of their smaller boats to take soundings. In the afternoon reinforcements started to arrive. It is noted that

Major General Broughton, brother-in-law of the governor, came into the city, as well as two companies of militia. One was under Captain Davies ,or David, and the other was under Captain William Cantey. Colonel George Logan and his mounted troopers also arrived. A strict watch was kept up throughout the day, but nothing of much importance happened. This seemed to be the calm before the storm.

Monday, August 26
The militia was marched out of the city fortifications and set up quarters about a half mile from Charles Town. The reason for this was because of the lingering specter of yellow fever, so they were put far enough away to give them piece of mind, but close enough to call should the fighting start.

Perhaps the biggest news of the day was the arrival of Governor Nathaniel Johnson. At the time of the alarm, he had been in the country at his plantation, Silk Hope. The governor viewed the defenses, gave the necessary orders and, perhaps most importantly,

Governor Nathaniel Johnson (1645–1713). *From the collections of the South Carolina Historical Society (SCHS).*

lent hope to the defenders. He was a known military man with experience in war. It is remarked by a writer that "his presence gave great encouragement to us all having strong confidence in his courage and conduct."

The French and Spanish were anchored off Folly Island, while their smaller craft continued to take readings. Perhaps expecting a nighttime raid, the militia was called back into the city.

Tuesday, August 27
The militia marched back out of the city. Early in the morning another camp was set up about a quarter mile distant of the city with the newly arrived companies of Captain Hearn and Captain Drake from over on James Island.

That evening the ships came over the bar, having unlocked the secrets of Charles Town Harbor, much to the horror of its citizens, who had hoped for a few more days. This was not to be, and the accounts state that as the invaders had a fair wind and tide, it was expected that they would shortly storm the city. All the available militia were brought into the lines and ordered to be ready to receive the enemy.

While preparing for the squadrons' arrival, Governor Johnson got word that another militia company had arrived and was in need of transport. Captain Fenwick's company was on a neck of land lying between the Wando River and the sea, and was ready to join in the defense. Anxious to have all available hands, a sloop, possibly the *Flying Horse*, was sent to ferry them over to the city. The squadron tried to block the sloop, but was unsuccessful; Fenwick's men arrived safely in Charles Town.

As Governor Johnson braced for the attack, he realized that the time had come for him to proclaim martial law. Immediately, all the taverns were closed and all the ships in the harbor were impressed into public service. If the *Flying Horse* had not been drafted before, it certainly was now, taking orders from the governor.

Governor Johnson also ordered that every window in the city be illuminated as guard against a night attack, and perhaps a

show of solidarity to their attackers. Every night for the rest of the invasion, lanterns and candles were placed in the windows, burning until dawn.

But instead of hitting the city, the squadron inexplicably anchored off Sullivan's Island. It was not until after the invasion was foiled that it was discovered they were still waiting for the missing *Brillante*.

Wednesday, August 28

The Santee company under the command of Captain James Longbois arrived. In my opinion this is one of the more interesting aspects of the invasion. There was a group of Huguenots, some of whom probably remembered the religious persecution in France, arriving to fight against their former countrymen. Captain Seabrook's company also joined the assembly of militia.

Early in the morning, Captain Stoel got the bad news. Governor Johnson had just had a council of war and it was decided that all the available ships in the harbor, a brigantine and two sloops, would be lashed together to create a fire ship. Basically, a fire ship was a ship filled with combustibles, deliberately set on fire and steered (or, if possible, allowed to drift) into an enemy fleet in order to destroy enemy ships or to create panic and make the enemy break formation.

At close to noon, the French sent a messenger under a flag of truce to Charles Town. What follows is one of the most dramatic incidents of the invasion. This envoy requested an audience and was taken into

Author's collection.

25

Granville Bastion, where he was to be held until Governor Johnson could arrive to speak with him.

A popular story has come out of this incident that may not be factual. The story goes that the French envoy was taken to Half Moon Battery first. Standing in front of the battery in formation were roughly 1,400 militia that had gathered to protect the city. The envoy was then blindfold and marched to Granville Bastion. While he was being escorted away, the same 1,400 militia hurried ahead and fell into ranks again at the next site. So when the envoy had his blindfold removed, he was greeted to another display of armed militia ready to defend their city. On the way out, the same game was played. Of course, he didn't realize it was the same men, and this would leave him with the impression that Charles Town had twice as many men as it really did—misinformation that they hoped he would share with his superiors.

Perhaps it's not true, but we don't know for sure, and it's certainly possible. Governor Johnson arrived at Granville with an interpreter, and the envoy presented his demand: In the name of the king of France, surrender the town and country, and submit to being prisoners of war. Governor Johnson had one hour's time to answer.

The basic tone of Governor Johnson's reply was that he did not need an hour, and he refused the demand outright. Too much English blood and sweat had gone into colonizing South Carolina, and if the French and Spanish wished to win and enter Charles Town it would have to be by force of arms, Johnson proclaimed.

Having his answer, the envoy was rowed back out to the flagship, the *Sun*. The siege would go on another day.

Thursday, August 29

Scouts reported in the morning that the French and Spanish had landed men on the neck of land between the Wando River and the sea. Shortly thereafter, several smoke trails were spotted coming up from the vicinity of Colonel Dearsley's Creek. What the French and Spanish torched were two abandoned vessels they happened upon that had been riding in the creek.

Anxious to halt their depredations, Colonel Risbye and Major Parris were ordered to detach one hundred men and go over and attack. Before they could execute the order, it was countermanded. It was thought better to let the enemy continue their raid, at least for the evening, and attack them in the morning when they least expected it.

While one group of the enemy was out in the Mount Pleasant area, another group of one hundred had been reported on Boones (or James) Island. Once again, smoke curled up; the raiders had looted and set afire a house.

Captain Drake's company, along with several Indian allies, was sent over to deal with this detachment. The boat that had dropped the raiders off spotted Drake and his men coming and fired one of its cannons. This was the signal to get back aboard with all haste. Several Indians who were friendly to the English, likely Yamasee, were with Captain Drake. They ran ahead of the English and attacked the raiders as they retreated. Several shots were exchanged, and two or three of the enemy were wounded before they managed to get back out on the water.

Friday, August 30

The important news on the morning of Friday, August 30, came from an African American man who arrived from the Wando neck area. The man notified the authorities in Charles Town that another raiding party was ashore, about 160 men had been on land all night and that they had killed a great many cattle, fowl and other livestock and were apparently drinking and feasting.

Governor Johnson commanded Captains Fenwick and Cantey with about one hundred men to face this new threat. This time the plan was to land undetected, get behind the raiders and cut off the retreat back to their boats. Fenwick and Cantey managed to land at Hobcaw without being spotted. They were able to approach the small detachment of enemies in camp at Rowler's Plantation. Apparently they were so stealthy that they were able to come right up to the fence of the plantation where the raiders were encamped and spread out in a firing line before being noticed.

SPANISH SOLDIER.

Author's collection.

The detachment saw that they were outnumbered and fled, dodging the shots of the English militia. The chase stopped near Gills Plantation, and it was here that the first small detachment of raiders on the run reunited with a second detachment. This wasn't the main body, but apparently their numbers were swelled enough to allow them to make a stand. An eyewitness account said that the enemy rallied and "faced us, disputing the ground for some time, exchanging several volleys. Wanting to end the fight, the English militia rush their opponents huzzaing loudly. This causes these two groups to break, and the retreat starts once again, this time both detachments running." The same eyewitness stated that "they gave ground and in great disorder fled."

The retreat and pursuit lasted for another mile, until the raiders reunited with the main body at Hartman's plantation. Here, the drama repeated itself. The English militia lined up on one side of a large open field, and the French and Spanish raiders lined up on the other. An observer tells us,

> *Captain Fenwick and Captain Canty drew up their men full of eagerness and desire at sight of the enemy to fall upon them and advancing within half musket shot poured in their volley, which the enemy sustained and returned theirs, but seeing our men running and huzzaing with a desperate resolution to engage them they immediately quit the field and fled away in great disorder and confusion, but they being prevented from heading over the creek, the greatest part of them fell into our hands and begging*

quarters were made prisoners of war, others attempting to escape by swimming the creek were drowned to the number of 7 or 8.

In the aftermath of the battle it was determined that there were nine dead on the battlefield as well as the seven or eight that had drowned. Thirty-three others were taken prisoners. It should be noted that it was at this running battle that the English suffered their only fatality of the entire invasion, William Adams, formerly of New England.

Although this was an important victory, it wasn't decisive. About sixty of the raiders made their escape back to the squadron.

Saturday, August 31

This day it was the navy's turn to fight. Colonel William Rhett, now dubbed vice admiral, raised the Union flag on the *Crown.* Also with him was the *Mermaid,* a ship under the command of Thomas Cary, the governor of North Carolina who happened to be in town before the invasion on personal business. The *Richard*, the *Flying Horse*, the *William* and the *Seaflower* formed the rest of the Charles Town squadron. The *William* was to be the sacrificial lamb; it was the one vessel filled with combustibles. In this formation they went out to challenge the invaders.

You will never guess what happened next.

The squadron saw the attackers and decided to run. An eyewitness writes that the enemy, "seeing us make towards them in great haste and confusion go out under sail, and in very little time, by the help of a favorable wind and tide got" over the dangerous bar and out of sight.

This fair wind and tide did not hold—the weather quickly soured. Vice Admiral Rhett had planned to pursue and destroy these tormentors, but the inclement weather forced him to call off the pursuit. This was certainly a signal victory, but Governor Johnson worried that the threat had not yet passed. Charles Town was still locked down under martial law, and that night the windows were again illuminated.

Sunday, September 1

When it became daylight, Captain Watson in his ship *Seaflower* searched the area and found fourteen Frenchmen in the Wando area flagging him down. These men were survivors of the firefight a few days earlier who had been left behind. They were quickly snapped up and added to a growing list of POWs.

Governor Johnson, sensing the crisis had indeed passed, ended martial law. It turns out this was perhaps premature. Remember the *Brillante?* In what probably seems hours ago I related the story of the duel between the *Flying Horse* and the *Brillante.* This ship's absence had given the French and Spanish pause and delayed their invasion, perhaps fatally. It supposedly contained the best men and all the supplies.

On Sunday word came to Governor Johnson that an odd vessel was riding anchor in Sewee Bay to the north, and that a great many men were landing. From the prisoners in their possession they were able to surmise its identity. The *Brillante* had finally arrived. Charles Town would have to prepare for at least one more day of fighting.

Monday, September 2

As soon as it was light, Captain Fenwick and his militia company started a forced march to Sewee Bay by land. Vice Admiral Rhett aboard the *Seaflower* and Captain Stoel and the *Flying Horse*, eager for a rematch, went to intercept the *Brillante* by sea. The weather was still foul, so not much distance was covered.

While on the overland march, Captain Fenwick was joined by local guide Mr. Motte, whose knowledge of the terrain helped them make better time. In the afternoon, Fenwick's Indian scouts reported that about two hundred of the enemy, troops from the *Brillante*, were at Mr. Hollybrush's or Mr. Allen's plantation ahead. Although Captain Fenwick was outnumbered about five to one, he decided to attack. Yet again, the pattern repeated itself: the charge broke the French and Spanish and the retreat started. The fighting at this location was apparently fierce. Between fourteen and sixteen were killed or wounded, and another sixty were captured.

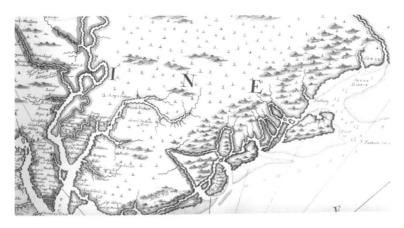

Section of 1711 map showing Charleston peninsula and Sewee Bay area—the final scene of the 1706 invasion. *Courtesy of Library of Congress.*

At roughly the same time, the *Seaflower* and the *Flying Horse* came upon the *Brillante* anchored in Sewee Bay with its yards and top masts down. Upon seeing the two ships, the *Brillante* surrendered. Another eighty or ninety prisoners, including the French land general of the invasion, were captured.

This would effectively end the invasion of Charles Town. The next several days were spent bringing in prisoners. The *Flying Horse* entered the harbor for a third time, bringing the captured *Brillante* with it as a trophy. Charles Town had been saved, and the harbor was once again open to friendly traffic. As can be imagined, the mood in the city was jubilant. In the midst of the festivities, weeks later, a reverend arrived in Charles Town. He wrote, "Upon my first landing I saw the inhabitants rejoicing; they had kept the day before holy for a thanksgiving to almighty God for being safely delivered from an invasion from the French and Spainards."

When it was all tallied, the invasion of 1706 cost the Spanish and French roughly a couple of hundred killed and wounded, about three hundred captured and the loss of one ship. When compared to the English loss of one death, this was a clear-cut victory.

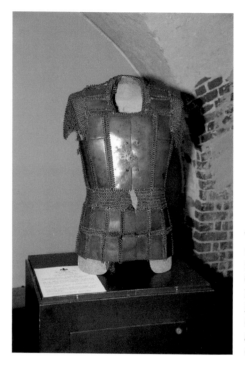

This vest taken from one of the 1706 Spanish invaders is currently on display at the Old Exchange and Provost Dungeon in Charleston. *Photographed by David Harley, Creative Imaging. Courtesy of the Colonial Dames, Charleston Chapter.*

Perhaps the best summary of the account comes again from someone who lived through the invasion. "And through the Providence of Almighty God, the malicious designs of our enemies are defeated, and their fleet like a second Spanish Armada."

This would not be the last time the Spanish, French and English would come into conflict. Queen Anne's War ended in 1713, but there would be other hostilities and feuds. The turbulent colonial period would continue, and thanks to the bravery of its defenders, so would Charles Town.

THE STONO REBELLION, 1739

To escape death the slaves hid.

Moments earlier they had been secure; nearly one hundred of the newly liberated had gathered in this cleared field by the water to sing, dance, sound the drums and drink. Stretching nearly twenty miles behind them was the wake of their violent rebellion; a bleak collection of charred and smoking houses, their trampled grounds littered with castoff spoils. The bodies of the former inhabitants lay alongside this domestic debris: men, women and children, all murdered.

Just the day before they had been nothing but chattel; lifelong possessions to be worked, sold or bred like any other animal. Today they had cast that role aside. Their captors and their families, along with anyone in their path, had been killed, their property plundered or destroyed. But unless they left this country, they would sooner or later be executed or returned into bondage. Today was the beginning of their march out of the lands of the English and into the lines at St. Augustine where the Spanish empire waited to crown their efforts with freedom.

It had seemed possible. They had been under arms and on the move since before sunrise and now as the afternoon faded they still remained unopposed. The original band of twenty had swollen to five times its number, and more were likely to arrive, attracted by the din of the camp.

Then out of the woods the white soldiers came upon them, firing thunderous volleys. They fought back but too many of them, those forced unwillingly from their masters' fields and homes, or those who were simply afraid, fled when it began. Those who stood their ground were targeted and killed.

Sensing the end of the insurrection, a handful chose to hide where they were. Their place of refuge was nearly in the center of this newly christened battlefield: a stout oak tree, its trunk split far enough apart to create a hole. In the confusion, while the others continued their violent struggle, and screened by a haze of thick gun smoke, the group slipped through this opening unnoticed. Inside this hollow wooden refuge, hearts pounding, they were assailed by the noise of the struggle outside. Dozens of different voices rose on top of each other: some screamed in English, some in tongues from another continent; guns belched lead shot that struck earth, wood or flesh.

It had begun before dawn on Sunday, September 9, when twenty slaves assembled. They met on the western branch of the Stono River, along a sluggish tidal creek known today as Wallace River. Only the name of their leader is known, yet even this is suspect. According to a historical account the "one who was called Jemmy was their Captain"; others identified him as Cato.

They moved first to Hutchinson's Store near the bridge spanning the marshes. The shopkeepers inside were killed—decapitated, their severed heads left upon the front steps. The store was looted, its wares of guns, powder and shot divided among them. The firearms would have been handled with an air of familiarity. It has been speculated that some of the slaves may have been ex-soldiers from the Kingdom of Kongo area of Africa; others were likely trusted cattle ranchers who routinely carried weapons in their imposed duties.

Muskets primed and shouldered, they began their march. Their backs were to Charles Town, one of the most important port cities in British North America. Although it was just over twenty miles

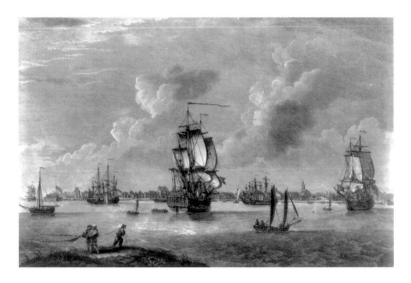

A mid-eighteenth-century view of Charleston. News of the slave revolt caused a massive upheaval in the Lowcountry. Refugees from the country packed into the city, afraid for their lives. The revolt would affect the way Charleston planters interacted with the slave populace for generations. *Courtesy of Library of Congress.*

away, they were not interested in that place; their destination was the rumored haven deeper south, in St. Augustine.

The insurgents struck the settlers along their route of escape. At the Godfrey place, a father, son and daughter were executed, their house sacked and then razed. On the southward bend, Wallace's Tavern and its innkeeper were spared, because some remembered him as a kind man. His neighbor, Mr. Lemy, was not as fortunate. Lemy and his wife and child were killed, his house set ablaze. This course of murder, plunder and destruction was repeated at Colonel Hext's, Mr. Sprye's, Mr. Sacheverell's, Mr. Bulloch's and Mr. Nash's.

To prevent the news of the uprising from getting out, any travelers the slaves met on the road were pursued and killed. By an incredible twist of fate the lieutenant governor of South Carolina, William Bull, happened to be making his way back to Charles Town on this same road on the same day. "I was returning from Granville County

According to some accounts, the rebels flew white banners and beat on drums while crying out, "Liberty!" As the word spread, their numbers grew. Some slaves willingly joined, while others were forced into the ranks by threats of violence. *Courtesy of Beth Burkett, Charleston County Parks and Recreation (CCPRC).*

with four gentlemen and met these rebels at eleven a Clock in the forenoon, and fortunately deserned the approaching Danger time enough to avoid it." Bull and his party fled the scene to spread the alarm—the militia had to be rallied!

In the mid-afternoon, Jemmy's men, now estimated numbering sixty to one hundred, stopped near the Jacksonboro Ferry on the Edisto River. It was here they began to sing and dance, possibly to celebrate their victory or to attract others. Or perhaps, as some scholars have suggested, the "dancing" was actually a form of an African military tradition. A sense of security permeated the camp. Some were drunk off of stolen liquor; others rested, exhausted from the affairs of the day. The eyes of the alert watched the activities of the camp rather than the approaches.

Since his narrow escape in the morning, Bull and his companions had spread through the area, alerting the inhabitants

According to a November 29, 1739 report, "A negro man named July belonging to Mr. Thomas Elliott was very early and chiefly instrumental in saving his Master and his family from being destroyed by the rebellious Negroes." In reward for his service, July was granted his freedom. *Courtesy of Beth Burkett, CCPRC.*

to their peril. The sense of dread must have spread on frantic wings from village to town to settlement. A slave uprising, the black majority in arms against the white minority, had been a long-held fear. To see it realized in their lifetime was a waking nightmare.

A letter written a few months later provides some details of the alarmed populace's response: "The first method we took was to secure our ferries and passes by guards; and to send out a body on the scout." Upon finding the slave camp, this force launched its attack. "The number was in a manner equal on both sides and an

Calling the slaves to labor. In 1739, slaves worked six days a week, usually from sunrise to sunset. Sunday was given to work on their own plots or to rest. September 9 was likely chosen for the rebellion because it was a Sunday. See Dr. Smith's landmark work *Stono: Documenting a Slave Revolt. www.Archive.org.*

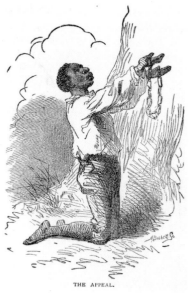

THE APPEAL.

In 1739 there were approximately thirty-nine thousand enslaved Africans in South Carolina. This accounts for a staggering 65 percent of the total population. With the rise of crops such as rice, indigo and later cotton, the numbers of the enslaved increased. *Author's collection.*

engagement ensued in such a case wherin one fought for Liberty and Life, the other for their country and everything that was dear to them."

"The Negroes were soon routed though they behaved boldly," one of the soldiers recalled afterward, while another went into greater detail: "They gave two fires, but without any damage. We return'd the fire and bro't down 14 on the spot."

The initial encounter was over. The remainder of the slaves dispersed into the wilds, or tried to return to their owners in hopes that their absence had not been missed. A ranger from Fort Augusta tells of a dramatic encounter that occurred between slave and master on the battlefield: "They all made off as fast as they could to a thicket of Woods excepting One Negroe fellow who came up to his Master his Master asked him if he wanted to kill him the Negroe answered he did at the same time Snapping a Pistoll at him but it mist fire and his Master shot him thro' the Head."

One chronicler of the event remarked on the behavior of the militia: "They did not torture one Negro, but only put them to easy death." A secondhand account from later that month remarked on the slaves: "About fifty of these villains attempted to go home but were taken by the Planters who cut off their heads and set them up at every mile post they came to."

Those closer to the event put the number of the escaped at thirty. These were hunted and ferreted out by the militia, rangers and hired Indian trackers. "Within two days kill'd twenty odd more, some hang'd, and some gibbeted alive. A number came in and were seized and discharged." In the aftermath the slaves who had helped their masters were rewarded; those who could prove they had been coerced kept their lives, but were returned to servitude.

A week later, a surviving body of fugitives clashed with the militia thirty miles south of the battlefield. Despite the continued patrols and vigilance, insurgents remained at large. It was not until 1742 that one of the surviving ringleaders was found and executed.

Despite the best efforts, rumors lingered of a successful handful that succeeded in reaching St. Augustine. No records in the Spanish archives note any such auspicious arrival, so this remains merely a tradition. About seventy-five South Carolinians, slave and free, were casualties of the rebellion. The Stono Rebellion changed not only the face of slavery in Charles Town and South Carolina, but also deeply affected all of the English colonies.

Were the slaves in the oak discovered? Were they executed or were they part of the "fortunate" set, those returned back to slavery? Or did they creep out of the tree afterward, when the battlefield was emptied of warriors? Did any of them make it to Florida? Their fate is unknown. In fact, it is only in long-held local folklore, the same realm as the rumored escapees, that the "Battlefield Oak" even exists. No contemporary report or later historical account mentions the oak. Attempts to find such a tree in the modern age have yielded no results. The oak may yet be found, or it could be that the story has changed with the telling. The tree could be not in one place but in many, across several states, reflecting any one of the places of refuge sought by the rebels in their desperate bid for freedom.

ELIZABETH TIMOTHY

*The First Female Newspaper Publisher
in the United States*

As the year 1738 drew to a close, the loyal readers of the *South-Carolina Gazette* speculated on the fate of their beloved newspaper. Since 1732, the *Gazette* had provided the latest domestic and international news and also served as a venue for merchants and locals to sell their wares. In late December of 1738, the man responsible for publishing the paper for the last four years, Lewis Timothy, died from an "unhappy accident" and was laid to rest at St. Philip's. Some surmised that his passing signaled the end of the *Gazette*'s run, while others were of the opinion it would survive, but only if another entrepreneur decided to assume the duties of printer.

On January 9, 1739, a new edition of the *Gazette* was released. It contained a remarkable message from the widow Elizabeth Timothy. "Whereas the late printer of this *Gazette* hath been deprived of his life…I take this opportunity of informing the publick that I shall continue the said paper as usual." This was something unheard of in colonial America: a female newspaper publisher. Perhaps to soften the shock of crossing the gender lines, Elizabeth added in her statement that she hoped that those who had supported the *Gazette* in the past would continue to do so, as it would benefit the deceased Lewis Timothy's "poor afflicted widow and six small children and another hourly expected."

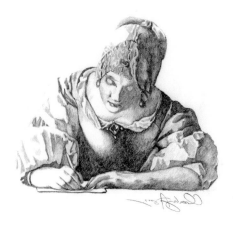

Elizabeth Timothy (?–1757), newspaper pioneer. *Courtesy of Junior Achievement of Central South Carolina, Inc..*

Little is known of this newly widowed and pregnant mother who became a publishing pioneer. Lewis Timothy's mentor and founding father, Benjamin Franklin, remarked that she was born and bred in Holland. She and her husband, Louis Timothee, a French immigrant from Rotterdam, along with four children, arrived in the New World in 1731. They resided in Philadelphia, and their names were anglicized: Louis became Lewis, and Timothee became Timothy. During their stay in Philadelphia, Lewis began a business relationship with Franklin, the famous printer. Aware of a need for someone capable to take over the defunct *South-Carolina Gazette*, Franklin sent Lewis and family to Charles Town. In late November of 1733 they had arrived in the South Carolina capital and had begun to settle in their offices and pressroom. The first edition under Timothy's stewardship ran on April 6, 1734.

Before leaving Philadelphia, Franklin and Timothy had made an agreement that if Lewis were to die, his son Peter was to take over as publisher. However, Peter (in his early teens at the time of his father's death) was too young for such a responsibility, so Elizabeth vowed to keep the paper and family afloat until he came of age. In a nod to his eventual succession, and perhaps as a way to stave off gender discrimination, she crowned the masthead with

Masthead of *South Carolina Gazette. Author's collection.*

Peter's name. She surrendered the paper to her son in 1746 after a successful seven-year run.

Benjamin Franklin later remarked,

> *In 1733 I sent one of my journey men to Charleston…He was a man of learning, and honest, but ignorant in matters of account: and tho' he sometimes made me remittances, I could get no account from him, nor any satisfactory state of our partnership while he lived…On his decease the business was continued by his widow, who being born and bred in Holland, where as I have been informed, the knowledge of accounts makes a part of the female education, she not only sent me as clear a state as she could find of the transactions of the past, but continued to account with the greatest regularity and exactness every quarter thereafter, and managed the business with such success, that she not only brought up reputably a family of children, but at the expiration of the term was able to purchase of me the printing house and establish her son in it.*

Peter would continue publication of the *Gazette* until it was disrupted by the political turmoil of the American Revolution in 1777. Oddly enough, Elizabeth would not be the last of the Timothy women forced to manage the *Gazette* under tragic circumstances. Peter was lost at sea in 1782, and his widow Ann published the paper until her death in 1792. Ann renamed the paper *State Gazette of South Carolina*. Her son, Benjamin Franklin Timothy, renamed it again in 1794. The newly christened *South Carolina State Gazette* was published until 1802, when the newer and larger *Charleston Courier*, later part of the *Post and Courier*, ended the reign of the *Gazette*.

THE OTHER BATTLE
OF FORT MOULTRIE

Colonel Thomson's Defense of Breach Inlet

May 1776 ended with ill omens. On Tuesday, May 28, 1776, a violent storm cloaked Charles Town harbor with rain, wind and thunder. Riding out the weather, bobbing among the waves, was a brigantine, the *Comet*. This ship belonged not to the British but to the fledgling navy of a fledgling country: the United States. A bolt of lightning arced from the sky, striking the vessel; the mainmast was "shivered," killing one unfortunate sailor.

The weather shortly cleared and the *Comet* limped to the docks in safety, but as this storm subsided another tempest raced southward to fill the void. Barely two days later, fifty ships, flying the colors of the King of England, were bearing down on Charles Town. These ships rode low in the water, their hulls burdened with thousands of soldiers and all of their implements of war.

On May 30, South Carolina locals living along the coast spotted the armada six leagues north of Sullivan's Island. Its target was all too apparent. An express rider raced through the countryside to the gates of Charles Town to spread the alarm. It was the next day before the authorities in the city knew their situation. They had suspected the attack to come, but had hoped for more time to prepare themselves. Only hours after the news arrived, a forest of sails began to spring up just outside the harbor.

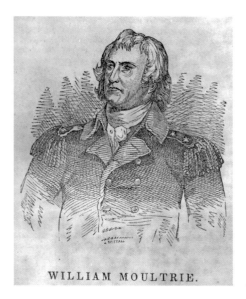

WILLIAM MOULTRIE.

General William Moultrie (1730–1805). Moultrie was in command of the palmetto fort, also known as Fort Sullivan, on June 28, 1776. Shortly after the battle, it was renamed Fort Moultrie in his honor. *www. Archive.org.*

William Moultrie wrote of the effect of this news:

The sight of these vessels alarmed us very much, all was hurry and confusion, the president with his council busy in sending expresses to every part of the country, to hasten down the militiamen running about the town looking for horses, carriages, and boats to send their families into the country; and as they were going out through the town gates to go into the country, they met the militia from the country marching into town; traverses were made in the principal streets; fleches thrown up at every place where troops could land; military works going on every where, the lead taken from the windows of the churches and dwelling houses to cast into musket balls, and every preparation to receive an attack, which was expected in a few days.

The authorities knew that time was of the essence. President (governor) John Rutledge rode out from the capital to inspect its defenses. Two forts guarded the city. Venerable old Fort Johnson

A MINUTE-MAN.

Many South Carolinians who fought in the American Revolution left behind their homes and families to serve in the military. *Author's collection.*

on James Island watched the south as it had for nearly seventy years. To the north on Sullivan's Island was a new fort. In fact, it was so new it was not even finished. Two of its walls were up and two were barely started. The entire structure, dubbed simply Fort Sullivan, was built out of the resources found in plenty out on the barrier islands: palmetto logs and sand. This would be the place the British would focus their attack. If it fell, Sullivan's Island could be converted into a post that could bottle up and eventually capture Charles Town. The workers inside the fort redoubled their efforts, aware that the attack could come any day now.

On Thursday, June 6, Major General Henry Clinton sent into Charles Town a message under a white flag. The message was a scathing indictment of the Patriots and their cause, dubbing it "a most unprovoked and wicked Rebellion." Clinton also called for the malcontents to dissolve their political bodies and offered "free pardon to all such as shall lay down their arms and submit to the Laws."

When this message had no effect, the campaign continued. The British commanders Admiral Peter Parker and Clinton debated

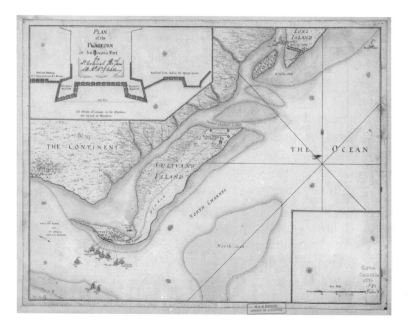

A plan of the attack of Fort Sullivan, later named Fort Moultrie, June 28, 1776. Breach Inlet, the area defended by Colonel Thomson and his men, is at the northern tip of Sullivan's Island. *Courtesy of the Library of Congress.*

the exact nature of the attack. Ultimately it was decided that this was not to be a strictly naval engagement; the battle to seize Fort Sullivan would be fought on two fronts. One front would be by sea, utilizing shipboard cannons. Nine of the armada were massive men-of-war, counting over 250 guns between them. A tenth boat was a bomb ketch, a ship that carried a large mortar used to batter shore fortifications. The second front belonged to the grunts. As the armada dueled with the gunners inside Fort Sullivan, the British infantry would storm the ruins from the rear.

Clinton feared that heavy surf and Patriot resistance would take a heavy toll on his troops if they tried to establish beachhead directly on Sullivan's. Landing on the adjacent Long Island (now Isle of Palms) seemed to be a safer alternative. A narrow ribbon of surf called Breach Inlet separated Long and Sullivan's Islands, but

this was not seen as an obstacle; it was thought to be shallow, only eighteen inches deep at low tide, easy to ford if necessary.

In early June the armada began disgorging flatboats and rowboats brimming with men. The Patriots were aware of this avenue of attack and posted men at Breach Inlet to monitor the activities of their enemies. The sentries on Sullivan's watched wave after wave of the British wade ashore, carrying or towing their supplies behind them. They slogged onto the northern tip of Long Island, or onto Dewees, a small island just north of Long Island.

On June 8, the order was given to fortify Breach Inlet with the riflemen of Colonel William Thomson and two pieces of artillery. While Charles Town was transformed into an armed camp, and men labored to put more of Fort Sullivan in place, Thomson and his men entrenched themselves among the dunes fronting Breach Inlet.

The landings continued for over a week. On June 16, Thomson reported to his superiors that of a small battalion from Dewees "every sixth man was carrying a tent, and that they are still landing as fast as the boats can bring them." The landing went on into the late afternoon, but was disrupted by a thunderstorm. Due to the heavy surf churned up by the foul weather, the small craft became difficult to manage; some of the British had to swim a half-mile to reach the shore.

The living conditions for the British massing on Long Island were horrendous. Doctor Forester wrote,

> *The suffocating heat…was the most insufferable I ever felt, not a breath of air stirring—thick cobwebs to push thro' everywhere, knee deep in rotten wood and dryed leaves, every hundred yards a swamp with putrid standing water in the middle, full of small alligators,—a thick cloud of musquitoes every where, and no place entirely free from Rattle Snakes.*

Life for the sailors aboard the ships must have not been much more pleasant, as several sailors from the *Ranger* deserted to the Patriots during this period. Valuable intelligence came with their

William "Old Danger" Thomson (circa 1725–1796). Originally from the upper Orangeburg district, this talented commander oversaw the arduous struggle for Breach Inlet. *Author's collection.*

defection—about 2,800 men made up the land force, and their commander was Clinton.

Realizing the Patriots now strongly defended Breach Inlet, Clinton looked for another avenue to reach Sullivan's. He "inspected every creek, channel, & access leading to Sullivan's Island from Long Island (from where it was thought an attack might be practicable), and observing that all the coast on the right of Long Island was bordered by an impassable swamp or morass with an interior channel running behind it." The only way was over Breach Inlet, which recent reconnaissance had shown was not eighteen inches at low tide, but seven feet!

They were entirely committed to the two-front attack at this point; some way had to be found to force the crossing. To feel out the situation on either June 19 or 20, a British brigade marched out on the beach directly opposite Thomson's position. According to the British, they appeared to be "entrenched up to their eyes." The number of Patriots facing them was also grossly miscalculated;

Clinton put the number at four thousand, when in fact Thomson never had more than one thousand men in the area at any one time.

The British hunkered down on the beach, waiting for an order to attack. They were too close. Thomson's riflemen took aim and selected their targets. A British sentry was shot through the leg. An officer "dressed in red, faced with black, and had a cockade and feather in his hat and a sword by his side," was also wounded. In retaliation, another British officer, Captain Trail, picked off one of their adversaries, shooting him through the head. At the end of the day, the British pulled back, out of range of the rifles, and the Patriots went back to work with shovels and picks, realizing the need to strengthen their defenses. A line of abatis, felled trees cut into sharpened logs, was placed around the perimeter.

The heightened danger did not stop Thomson's men from taking risks. President Rutledge had offered a bounty of thirty guineas to any of Thomson's men who "should first take one of the King's troops prisoner." Any information that such a prisoner could provide would be worth far more than this monetary reward. On June 24, the Honorable Richard Hutson wrote to Isaac Hayne that three riflemen had paddled over to Long Island two days earlier in a small boat for that purpose.

> *Two of them agreed to keep together, the other determined to go by himself. In the morning by twilight the one that was alone descried the two others at a distance, and imagining that they were the King's Troops, took up his gun to fire at them, thinking I suppose to kill one and then take the other alive: one of the others seeing his piece presented, was quicker than he was and shot him through the thigh, upon which he fell. They immediately ran up, dragged him to the boat, threw him and pushed off, all thinking he was one of the King's troops. They had got a considerable distance from the shore before the poor man was sufficiently recovered from his fright to speak. As soon as he spoke they discovered their mistake.*

Charles Lee (1731–1782). Lee served as Thomson's and Moultrie's superior during the June 28, 1776 engagement. Originally, he was against fighting the British at Fort Moultrie, calling the place a "slaughter-pen." *Courtesy of Library of Congress.*

Fortunately, this accidental wounding was not fatal; Hutson added that this unfortunate rifleman was "likely to recover."

The passage of this trio of riflemen had not gone unnoticed. The next morning a British patrol tracked their path and started across the breach. "As soon as our guard upon Sullivan's Island discovered them, they fired upon them with a field piece." A Patriot artillerist on the Sullivan's side shot a six-pound cannonball at this group; it went wide, splashing near one of the British ships. The ship pulled up anchor and went farther up a nearby creek to get out of range. This sparked a general engagement. The British fired by platoon upon the Patriot battery, calling up more troops to support them, and wheeled out their own set of six-pound cannons. The Carolinians advanced under this heavy musket and cannon fire, closing the distance across the Breach to fewer than two hundred yards, "keeping an irregular fire all the way." Every few minutes their cannon lobbed another shot over their heads toward the British. Hutson wrote of a gruesome accidental casualty incurred at this battery: "One of our men had one of his hands blown off by our own Field-Piece, which went off when he was loading it, owing to its not having been sponged. This firing continued for several hours, slowly dying down."

Despite the fact that hundreds, if not thousands of shots were fired, and two British soldiers and two Patriot soldiers were killed, this was deemed "a sham battle." An infuriated General Charles

Typical soldier of 1776. *Author's collection.*

Lee, overall commander of Sullivan's defenses, wrote a scathing letter to Colonel Thomson stating that "no vague uncertain firing either of rifles, muskets, or cannon is to be permitted." As to the three riflemen who had precipitated the whole affair, Lee admonished, "Soldiers running at random wherever their folly directs, is an absolute abomination not to be tolerated." Lee knew his resources, men and ammunition were in short supply and wanted both conserved.

The British cleared the area around an oyster bank and then covered it again with mounds of logs, sand and brush, converting it into a six-gun battery. Their counterparts on Sullivan's dug a second line of entrenchments five hundred yards back from the first.

Regardless of orders, sporadic fighting erupted again a few days later, this time monitored by Lee and President Rutledge. Hutson wrote on June 27:

> *The firing yesterday was between the troops on Long Island and our advanced Guard on Sullivan's Island across the Breach. They fired with Field Pieces and threw several shells. The President and General Lee were down there at the time. One of the shells bursted within a few yards of the President and he brought a piece of it up to Town with him. They did not do any execution and General Lee would suffer only two shots to be returned from an eighteen pounder which had been carried down there.*

While the land forces had been maneuvering and skirmishing, the armada had been making its way into the harbor. Jim Stokely, in his book *Fort Moultrie: Constant Defender*, wrote:

Sullivan's Island was thought to be the key to the geographically shielded harbor. A large vessel sailing into Charleston first had to cross Charleston Bar, a series of submerged sand banks lying about 8 miles southeast of the city. A half-dozen channels penetrated the bar, but only the southern pair could be navigated by deep-draft ships. A broad anchorage called Five Fathom Hole lay between the bar and Morris Island. From Five Fathom Hole shipping headed northward before turning west. At this point the channel narrowed considerably. To the south, a well-known shoal, called the Middle Ground, projected outward from James Island. Although part of this sand bank would later provide the site for Fort Sumter, its main significance over the years lay in its existence as an obstacle that influenced defensive strategy within the harbor. Just a thousand yards north of the shoal loomed the critical southern end of Sullivan's Island.

As the armada geared itself to reduce Fort Sullivan, the grunts prepared themselves for the task ahead. On June 28 the British decided to ambush a group of Thomson's men. They had selected the command under Captain Samuel Boykin made up of Catawba Indians, Native Americans from the Upstate. Watching the routine by which the Indians arrived and left the Breach area, they timed their attack to coincide with their next arrival. It did not have the desired results. William Henry Harrington, a Patriot rifleman, later wrote, "The enemy began to fire and aimed their shot directly at the Indians, who caused us to laugh heartily, by their running and tumbling, several of them whooping and firing their muskets over their shoulders backward. I confess, though the bullets poured around me, I laughed against my inclination."

At two o' clock that day the armada bore on the still-incomplete fort under the command of Colonel William Moultrie. The story of that engagement and the heroes it produced has been retold countless times in the 230-odd years since it happened. South Carolina historian A.S. Salley puts it more succinctly: "The battle of Fort Sullivan is American history." The battle at Breach Inlet and its heroes is not.

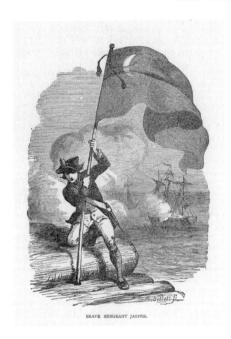

BRAVE SERGEANT JASPER.

This famous Currier & Ives lithograph shows Sergeant Jasper restoring Fort Moultrie's flag after it was shot away by a British cannonball. His brave act has become synonymous with that battle; Thomson's defense of Breach Inlet has not. *Courtesy of Library of Congress.*

The noise must have been deafening to Thomson's infantry on Breach Inlet. Dozens of large-caliber cannons were going off at once nearby, setting their ears ringing. Looking backward, they could see the cannonballs streaking from guns of the armada toward Fort Sullivan. Several plowed up geysers of spray as they skimmed off the water; others tore up swaths of earth, kicking up whirlwinds of sand. Others buried themselves harmlessly in the dense fibers of the palmetto logs of the fort. Soon each of the slow-moving ships looked like a miniature storm cloud, trailing strands of acrid gun smoke. Fort Sullivan returned a lethal hail of fire, splintering timber and men aboard the armada with deadly accuracy. The stationary fort, shrouded in a haze of powder-singed air, must have resembled an angry thunderhead.

As impressive as that battle was, the riflemen likely paid more attention to what was in front of them. The British were going into formation on Long Island. Two more of the armada's ships hugged the coast protectively to keep any of the colony ships, like the *Comet*,

away from the landing parties. Because of the depth of Breach Inlet, they had to cross using fifteen flat-bottomed boats, which could carry only one company at a time. To soften up the area before they landed and to cover their amphibious assault, Clinton ordered his own bombardment, echoing what was taking place on the southern end of the island. Like at Fort Sullivan, the smaller Patriot batteries at Breach Inlet returned fire across the Breach and raked the decks of the supporting ships.

Morgan Brown, a North Carolinian, described this fierce engagement: "Our rifles were in prime order, well proved and well charged; every man took deliberate aim at his object...The fire taught the enemy to lie closer behind their bank of oyster shells, and only show themselves when they rose to fire."

Clinton's hopes of having additional naval support for his landing were dashed when three of the ten attacking ships grounded on the middle shoal. The sniping continued throughout the day, even after Parker's armada turned away from Fort Sullivan, soundly defeated, in the evening. Seven hundred men reinforced Thomson's men at the Breach later in the afternoon, another reason why Clinton did not proceed with the offensive.

As news of the successful repulse of the British at Fort Sullivan was celebrated, the contest continued at the Breach. Clinton had kept his men under arms and at the ready all night. In the pre-dawn hours of June 28, they were told to prepare to board the flatboats a second time. Doctor Forster wrote, "Half the army was up to the knees in a swamp all the time expecting orders to cross the creek every minute."

Thomson's men steeled themselves for another day of fighting. At daybreak, something in the harbor was set afire: the *Acaeton*, one of the ships that had grounded on a shoal the day before during the fight. A quarter-hour later it exploded in a massive fireball. Parker had ordered the stranded ship destroyed rather than fall in the hands of the Patriots.

The events of June 28 are a matter of some controversy, or as author Patrick O' Kelly puts it, "What happened next may be one of the biggest cover-ups in the war." There are two distinctly

different accounts. The official British record claims that the troops did not attempt a crossing and there were no casualties. Dr. Forster wrote that the landing was attempted, but called off on the verge of success, much to the chagrin of the troops.

The Patriots have their own version, which seems to be corroborated by the accounts of several British sailors. In this version the landing proceeded, and Colonel Thomson waited until the boats were in close range and then opened with cannons and rifles. The eighteen-pounder sent grapeshot, pieces of jagged shrapnel, through the advancing flotilla. Under such heavy fire, and taking numbers of casualties, the attack was rescinded.

What truly occurred on June 28 is unknown. What is indisputable is that the British had been checked multiple times at Breach Inlet by a much smaller force and had taken a larger number of casualties. Had Thomson and his men failed at their duty, Fort Sullivan (soon to be Fort Moultrie) may have fallen, and with it Charles Town. The shock waves from the capture of this city would

AMERICAN RIFLEMAN.

www.Archive.org.

have greatly impaired Patriot morale in the crucial year of the Declaration of Independence, 1776.

However, the Breach Inlet battle is usually regarded as a footnote, a minor sideshow to the naval battle. Every year on June 28, Carolina Day is observed in Charleston. A procession of organizations march down Meeting Street to White Point Gardens and a speech is given extolling the virtues of Moultrie, Jasper and the "Spartan Band" that was inside Fort Moultrie on June 28, 1776. Wreathes are laid around the monument of Sergeant Jasper and, as of 2008, also around the new statue of William Moultrie. No such ceremony marks the battle of Breach Inlet or Thomson and his men.

THE EXECUTION OF ISAAC HAYNE, AUGUST 4, 1781

Colonel Isaac Hayne awaited his executioners. He was held prisoner within one of Charles Town's most magnificent buildings: the Royal Exchange and Customs House.

While Hayne waited, the citizens began assembling. The usual Saturday morning business seemed to have been forgotten or suspended for this solemn occasion. Hundreds of curious spectators clustered together, lining nearby Broad and Bay Streets. The throng just outside the provost kept a respectful distance from the soldiers who were already in place. There were nearly three hundred armed men facing them, the familiar red-coated British Regulars augmented by their military auxiliaries, including the Hessian, or German, troops.

The fact that such a show of force was necessary showed that the authorities expected trouble—and they had every reason to be concerned. Although the British had occupied Charles Town since May of 1780, a large portion of the population still embraced the Patriot cause. This was not the only element they had to be wary of. The Loyalists, those who stayed faithful to the king throughout the American Revolution, had turned out in large numbers as well. Pleas for leniency regarding Hayne had come from both of these camps.

A majority was unified in the feeling that Hayne's sentence was unusually severe and contrary to the rules of war. Such was the

Dungeon beneath the Exchange and Provost Building where Hayne was held prisoner. *www.Archive.org.*

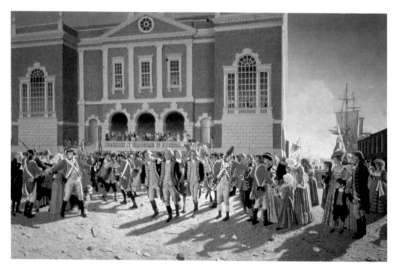

The Execution of S.C. Patriot Isaac Hayne, by Carroll N. Jones Jr. The original hangs in the Fireproof Building, headquarters of the South Carolina Historical Society. *From the collections of the SCHS.*

strength of this feeling that the conversation of the crowd, even on the appointed day, probably centered on the question of whether the execution would happen. There had been no formal trial; would the British carry out such a controversial verdict?

Hayne was summoned. Several guards led him outside. When he stepped into view of the crowd, the more optimistic likely experienced a split second of hope. Were the British setting Hayne free at last? Then they noticed that his hands were bound behind his back.

On September 23, 1745, Sarah Williamson Hayne gave birth to a son. It was decided that he would carry on his father's name, Isaac. After coming of age, the younger Hayne also continued another family tradition: he was active in the affairs of St. Bartholomew's Parish. In 1765 he married Elizabeth Hutson, daughter of Reverend Hutson of Stony Creek and later of the Circular Church. Hayne also came into his own as a successful planter. He oversaw several local plantations but called Hayne Hall, located four miles from Jacksonboro, home.

At the time of the American Revolution, Hayne was living in what one descendant later referred to as "easy circumstances." This existence of privilege and luxury was set aside when Hayne chose to join the Patriot ranks. In 1776 he served in the Colleton County militia with the rank of captain. After four years of war, Charles Town fell to the British. Hayne's men were not in the city when it was captured, but as part of the surrendering army they considered it their duty to disband. Some returned home, taking a formal oath not to fight again, while others vowed to continue the fight in the backcountry, outside of occupied Charles Town.

Hayne, however, did not have a choice about his future—he would have to brave the lions' den. Smallpox, one of the major killers of eighteenth-century America, had struck his family. Governor John Rutledge, writing about the affair, stated that "the deplorable condition of his wife and children being dangerously ill & the country wasted, had compelled him, for saving their lives to

get a physician & procure necessaries for the sick." Upon hearing of the arrival of the former enemy officer in the city, the British authorities demanded that Hayne either remain in Charles Town or sign an oath of allegiance to the Crown. With the fate of his family at stake, Hayne had no choice but to consent. Rutledge commented upon Hayne's decision: "He would submit to their government and take the oath, but must openly declare that he should consider it obligatory, only as long as their [British] protection would really be of benefit to him, or till the Americans would again get possession of the country."

Hayne was also concerned that he would be asked to fight with the British against his countrymen. James Simpson, a British agent on behalf of the commandant of Charles Town, reportedly told Hayne that "it was not expected that he should bear arms against the Americans, nor adhere to the allegiance any longer than that he should receive protection." Perhaps rather sarcastically, it was added that "when the regular forces could not defend the country without the aid of its inhabitants, it would be high time for the Royal army to quit it."

Political matters attended to, Hayne returned home to tend to his family. Despite his best efforts, smallpox claimed his wife Elizabeth shortly after his Charles Town visit. Two of his daughters—Eliza, eighteen months old, and Mary, four years old—shortly followed. He nearly lost a fourth family member from the disease; his son, William Edward Hayne, was expected to die, but miraculously recovered. In a later memoir, William Hayne recalled accidentally discovering the coffin they had purchased for him. William on the mend, Hayne remained quietly at home with his family, ignoring pleas from his former allies to mobilize the militia again.

By the summer of 1781, Patriot victories had significantly weakened the British presence in South Carolina. Only a small section of territory around Charles Town remained effectively in their control. With such a dramatic shift of power, Hayne felt the promise of British protection was hollow. Sure that it would only be a matter of time until they forcibly pressed him into British service,

1780 view of Charleston, with Exchange and Provost featured prominently. *www. Archive.org.*

Hayne declared his forced agreement at an end. He reentered the Patriot militia with the rank of colonel. Unfortunately, Hayne was shortly afterward captured while attending a military conference near Jacksonboro.

It was decided to make an example of this particular prisoner of war. The British thought that if they passed a severe sentence on Hayne it would discourage others from breaking their own oaths. Circumventing normal protocol, the death sentence was passed. Despite the tremendous public outcry, the authorities were determined to see it through.

William Hayne, at five years of age, recalled going to visit his father with his older siblings in the northeast room of the Exchange and Provost Building. For some reason the British had decided to place the coffin Isaac Hayne would be buried in within his holding cell. William's own narrow escape from a similar coffin must have burned this image into his memory, for in a memoir published in

BRITISH GRENADIER.

HESSIAN OFFICER.

Both images www.Archive.org.

the next century he was able to recall that the coffin laid out for his father was covered with "black broad cloth & lined with white."

The solders were called to attention. Hayne descended to the street and the procession began. According to eyewitness accounts, Hayne was not alone on that somber forenoon march; several of his closest friends had been allowed to remain by his side.

The soldiers escorted Hayne and his small loyal band through the city, past the multitude watching from windows or along the street. John Colcock, friend and legal counsel to Hayne, who was present in Charles Town that day, stated that numerous bystanders openly wept as Hayne passed. Their route took them out of the

city proper and past the elaborate line of defensive works where Calhoun Street and Marion Square sit today. They slowed to a halt at a site that would have been a stone's throw from the old Orphan House. A wheeled cart placed beneath a wooden scaffold was the centerpiece of this cleared area. Dangling from the end of the scaffold was a length of rope, its end twisted into a noose.

John Colcock related a conversation that took place between Hayne and one of his friends as the gallows came into view: "The instrument of his catastrophe appeared…a faithful friend by his side observed to him, 'that he hoped he would exhibit an example of the manner in which an American can die.' He answered with the utmost tranquility, 'I will endeavor to do so.'"

The soldiers formed a square, British to front and rear, the Hessians to the flanks. Hayne filed past them, climbed into the cart and the hangman looped the noose over his neck. His hands were untied, and he was able to shake hands with his friends who had come to say their final farewells. With his own hands, Hayne slid the hood down over his face. He gestured that he was ready; the cart trundled out from beneath him.

"Thus fell, in the bloom of life, a brave officer, a worthy citizen, a just and upright man, furnishing an example of heroism in death," Colcock lamented. Hayne's oldest son made arrangements to transport his father's body back to the family plantation on the Edisto River for burial. One of Hayne's last requests had been to be "decently interred among my forefathers."

This highly public execution was meant to break the spirit of the rebellious Patriots. It ultimately had just the opposite effect: it made a martyr of Colonel Isaac Hayne. His death became a rallying cry to all those opposed to British rule. His gravesite, now in the care of the state, remains a hallowed Carolina landmark.

THE BATTLE OF
PARKER'S FERRY, 1781

On August 30, 1781, General Francis Marion decided to go on the offensive. As usual, the odds were against his success. The British had more men, were better armed and were supported by something he completely lacked: cannons. Marion probably did not dwell long on his deficiencies. He had garnered his reputation and sobriquet, "the Swamp Fox," because throughout the American Revolution he had continually gone up against longer odds with much less, and come away triumphant.

By shadowing his opponents' movements for days, Marion had the chance to select the battlefield: a narrow, sandy causeway rising out of a swampy environ about a mile west of a place named Parker's Ferry. Forty yards off this causeway was a thick stand of trees and palmettos. Skirted with a dense layer of brush and high grass, it was the ideal spot for an ambush.

Marion ordered his men into position. Troopers armed with muskets, rifles and shotguns filed into the concealing foliage while several smaller units, a few of them mounted, took their places off the firing line. As they moved into position, they likely checked their weapons and powder, while several of them instinctively reached up to their hats to make sure that the white feather (which marked them as one of Marion's men) was still in place. Since many of them did not wear uniforms, it was easy in the confusion of battle to mistakenly fire, or be fired upon, by a comrade.

Top: Marion pursuing an enemy. *www.Archive.org.*
Bottom: Marion and his men in camp before battle. *www. Archive.org.*

Marion's ambush was in place when the British entered the area. At about sunset one of Marion's advance guards, or pickets, spotted something strange. A white feather sprouted out from a thicket up ahead. Suspicious, the guard called out, thinking the person an ally, expecting to get the appropriate password in return. There was no reply, and the firing started. After a few shots the British realized that they were outnumbered and retreated back down the causeway. For a moment Marion's design had come undone. He was probably mentally drafting orders for the retreat when the actions of the British suddenly changed his mind. Despite having been spotted by the British, and losing the element of surprise, the opposing forces continued to follow his plan. Accounts written after the battle state that although the British had gotten word that Marion was in the area, not one of the commanders at the time thought that they were facing anything other than another smaller band of partisans. This would lead them to make a fatal decision.

One of the British officers, Major Thomas Fraser, ordered a small group of his cavalry into the woods to dislodge their attackers. A handful of Marion's mounted troopers surged out from cover, down the causeway, to meet them head on. After a brief clash, Marion's horsemen withdrew as if overwhelmed.

Deciding to deliver the deathblow, Fraser led his cavalry in pursuit at full gallop. Waiting for the right moment, Marion finally gave the signal to spring the trap. Out among the trees, scores of weapons fired at once. Most of Marion's men had packed buckshot down into the barrels of their guns in anticipation of this encounter. The effect of this type of shot at such close range was ruinous. Soldiers in the king's cause fell from their saddles, wounded or dead. The innocent mounts suffered the most; numerous horses went down, throwing or pinning their riders as they collapsed onto the causeway or tumbled into the marsh.

Bravely rallying his men, Fraser attempted to wheel about to rush their foes in the trees. The effect was to pack his men closely together and thus expose them more. A second and third volley tore through their ranks. With no other options, Fraser ordered the retreat, but his only avenue of escape was down the causeway,

General Francis Marion
(1732–1795).
www.Archive.org.

past the length of the ambush. Scattered fire picked off more men and horses. At one point Fraser had his horse killed out from under him. Before he could get to safety, several of his own fleeing cavalry had ridden over him, leaving him bruised.

Fraser did manage to safely retreat, either by commandeering a horse or limping back into the lines on foot. While Fraser and the cavalry nursed their wounds, the British brought their infantry and an artillery piece up. Those of Marion's men who owned the longer-ranged rifles used them to great execution. The gunners around the cannon were killed or wounded before they could bring it to bear on the Patriots.

Although Marion held a strong position on the field, he ordered a retreat. Ammunition was running low; his men needed to rest and eat. Once again, he slipped away into the swamps, leaving behind a beaten and humiliated enemy. Marion lost one man killed and three wounded. By comparison, the British had eighteen killed with eighty more wounded. It should be noted that while the term "British" has been used, this is simply to simplify identification.

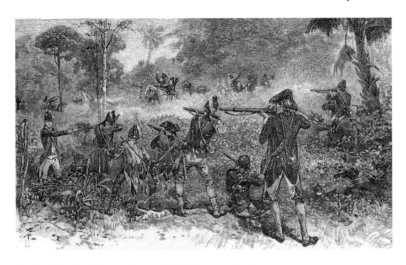

Battle of Parker's Ferry, August 30, 1781. *www.Archive.org.*

Almost all of the men who fought in this battle on either side were Americans, not British.

At least thirty horses were lost to the British because of this battle. While thirty may not seem a significant number, it should be remembered that horses were a scarce and extremely valuable commodity in South Carolina at this late phase of the war. The loss of these mounts would impair the British effectiveness just nine days later at the pivotal Battle of Eutaw Springs.

The Battle of Parker's Ferry was not a large affair, but it was a battle with greater, far-reaching consequences. The British loss further weakened their hold on the area, adding to the decision to entrench in Charles Town. The one-sided nature of the battle also served as salve for Patriot morale, which had been dampened by the highly public execution of one of their own, Colonel Isaac Hayne. It serves as an excellent example for the study of the type of fighting that took place in South Carolina during the American Revolution. Any student of Marion's campaigns would be well served to include a discussion of this battle in their work. Yet few accounts of the Revolution, even those with a focus on the South, mention Marion's ambush at Parker's Ferry.

In Broad Daylight

The Murder of Dr. David Ramsay

Dr. David Ramsay didn't notice William Linen as he passed him at the corner of Broad and Meeting Streets, near St. Michael's Church. Perhaps he was too tired to notice, the result of one of his many late nights hunched over the desk in his study. Whatever the reason, on the morning of May 6, 1815, Ramsay continued walking, probably heading back to his residence farther down Broad Street, while contemplating his most recent book project. Once they passed each other, Linen turned, withdrew the gun he had hidden under a handkerchief, sighted and fired. The large horse pistol must have spit fire and bucked in Linen's hand when the trigger was pulled. He had packed not one, but two bullets down into the barrel. One shot spun wildly, hitting the church; the other struck the sixty-six-year-old Ramsay in the back, mortally wounding him.

Chaos erupted on the streets at the sound of the gunshot. As a port city, Charleston had its share of trouble, but seldom in the middle of the day, in front of a church. Several people nearby rushed to Ramsay's side and carried him into his house. As his friends and family gathered around him, he insisted with careful deliberation that his assassin, Linen, not being in his right mind, shouldn't be held accountable for his actions. Ramsay lived for two more days, dying on May 8, 1815.

David Ramsay was born in Pennsylvania on April 2, 1749, the third son born to a couple of Irish descent. An exceptionally

Dr. David Ramsay (1749–1815).
www.Archive.org.

gifted scholar from a very young age, by thirteen he had already completed his classical studies and entered the sophomore class at the College of New Jersey, now Princeton. At twenty-one he began his training as a physician at the University of Pennsylvania.

After receiving one of the two prestigious degrees in medicine awarded to his class, Ramsay garnered a post in Charles Town with the help of one of his instructors (and future signer of the Declaration of Independence), Dr. Benjamin Rush. Arriving in 1773, his intelligence and charisma won him many friends among the city's elite. He embraced the Revolutionary fervor brewing in the Southern colony and joined the ranks of Christopher Gadsden's "Sons of Liberty."

Over the course of a few years, Ramsay became more of a staunch moderate than a firebrand. During the pivotal year of 1776, Ramsay was elected to his first political appointment: a seat in the state House of Representatives. Two years later, he was appointed as a member of the Council of Safety. On July 4, 1778, he delivered an oration to the citizens of Charles Town titled "The Advantages of American Independence," now considered the first such patriotic oration delivered on the Fourth of July.

Not all of Ramsay's service was political. As a surgeon to a local militia unit, his medical training would have proved valuable to the beleaguered defenders throughout the 1780 British siege of Charles Town. After a gallant but doomed defense, Charles Town surrendered to the overwhelming force and the city was occupied by British troops. During the occupancy, the British decided to quell dissent by rounding up the ringleaders of the revolutionaries.

Ramsay's high profile earned him this distinction. Ramsay, along with approximately thirty others, was taken from his home by dispatched troops and put aboard a ship. To keep the prisoners from inciting dissent, they were sent to the remote outpost of St. Augustine, Florida. Ramsay was held captive for nearly a year before being released.

Following the war, Ramsay returned to political service, including the State General Assembly and the Continental Congress. When his chosen party, the Federalists, fell from power in the 1790s, Ramsay was forced from the political arena into semi-retirement. However, he remained active in important roles with organizations such as the Charleston Library Society, the Medical Society of South Carolina, the Literary and Philosophical Society of South Carolina and the American Revolution Society.

Through his political connections, Ramsay worked alongside Henry Laurens, one of the most notable citizens of the Palmetto State. In 1787, he married Laurens's daughter, Martha. Ramsay had been married twice before, and both times had been left a widower. He and Martha would be married for a quarter of a century, giving birth to eleven children in the first fifteen years. In a time when marriages were often arranged for business purposes rather than love, the Ramsays' union stands as an exception. Letters exchanged between the couple speak of their deep affection for one another, referring to their life together as a "joint pilgrimage here on earth."

Even with a large family and a busy schedule, Dr. Ramsay continued his medical studies. In 1802, Ramsay decided to test a colleague's proposed cure for smallpox. Ramsay's faith in the cure must have been absolute: his trial subject was his own son, Nathaniel. The cure proved successful, and Ramsay is often regarded as the physician who introduced the smallpox vaccine to Charleston.

Ramsay's beloved Martha became ill in 1811. Knowing her time was short, she revealed to her husband that she had kept a secret journal. Ramsay thought very highly of Martha's journal and had it published after her death. Martha was buried at the Circular Congregational

Dr. Ramsay's house on Broad Street, circa 1925. Today it serves as law offices. *Courtesy of Library of Congress.*

Church, and *Memoirs of the Life of Martha Laurens Ramsay* was a success in Charleston and abroad, and was reprinted several times.

With a large family to support and little aptitude for financial affairs, Ramsay turned to writing. He was prolific, and his texts made lasting contributions to the field of history. His first two-volume set

was *The History of the Revolution of South Carolina, from a British Province to an Independent State*, printed in 1785. The second set, *The History of South Carolina*, was published in 1809. He is also credited as the first biographer of founding father George Washington, in the publication *Life of Washington.*

Dr. Ramsay's involvement with his murderer began years before the fateful encounter in front of St. Michael's Church. William Linen, a tailor by profession, was a former patient of Dr. Ramsay's. The troubled man had been arrested for assaulting his lawyer and threatening judges and jurors. When Linen was brought before the courts for examination, Dr. Ramsay and a colleague found him to be insane. Upon their recommendation, Linen was institutionalized. After a period of confinement, the disturbed Linen seemed to show signs of improvement. The prognosis was premature: soon after his release he began to exhibit signs of instability, making verbal threats against Dr. Ramsay.

Linen's violent obsession culminated in the May 6 attack. He was apprehended and placed in the city jail. In 1820, Adam Hodgson, a journalist from Liverpool writing on social reform, visited the Charleston jail. On arrival, he found the turnkey intoxicated. Hodgson then turned to the prisoners for information. One of the prisoners he questioned was Linen. "I saw and conversed with the murderer of Dr. Ramsay, the historian," Hodgson wrote. "He has been confined in prison since, and is a pitiable object." Linen was imprisoned until his death in 1821.

Ramsay's death was mourned throughout the nation. An obituary in the July 1815 issue of the *North American Review* read, "Doctor Ramsay was the most distinguished literary character of the Southern States, and has published several valuable works." Many prominent societies acknowledged Ramsay's membership by resolving to "wear mourning for thirty days." His friend, Robert Y. Hayne, gave his eulogy. In dedication, Hayne also supported, to some measure, the eight children Ramsay left behind. Hayne spearheaded the posthumous publication *History of the United States: From Their First Settlement as English Colonies, in 1607, to The Year 1808* for the benefit of the Ramsay heirs.

Ramsay's body was laid to rest next to Martha's in the family plot in the graveyard of the Circular Congregational Church. The stone marker that once bore his name has fractured and fallen, but Dr. Ramsay's contributions as one of Charleston's leading Patriots, scholars and pioneers live on.

THE ATTEMPTED
BOOTH ASSASSINATION, 1838

J.B. Booth stared out at the water, pondering a dark subject. He was on the promenade deck of the *Neptune*, a steamship plowing along the coast from New York to Charleston. It was evening, and most of his fellow passengers were clustered together in the dining area. They were talking about the same thing people always talk about at the table: politics, the weather, the quality of the entrées. Only moments ago Booth had been seated among them. Unable to bear it any longer, he stood up and excused himself from their company, making sure to bid an authentic, measured good evening to Thomas Flynn, his watchful traveling companion. All too easy for one of the most gifted actors of the age.

Now he was free to meditate upon Conway in solitude. Poor doomed Conway. Ten years ago, William Augustus Conway, a fellow actor and friend, had committed suicide at almost this same spot. It was not long before Booth knew what had to be done.

While the captain generally ate with passengers, the crew of the *Neptune* usually dined in shifts away in another area. Several of the crew were about the ship that night performing their duties when some of them spotted Booth as he lowered himself from the promenade. Hanging by the railing, he hung suspended just feet over the rough waters of the Atlantic.

The captain was quickly summoned from dinner, as was Flynn; the rest of the curious passengers came of their own accord.

Junius Brutus Booth (1796–1852). This Matthew Brady photograph shows Booth in theatrical costume. He performed in Charleston several times over the course of his long career. *Courtesy of Library of Congress.*

In turns, all three would try to talk Booth back topside. Flynn probably blamed himself; Booth was his charge, after all. Since last Wednesday he had tried to soothe his friend's anxious mind and watch over him. He seemed to have gradually improved, so when he left the table that evening Flynn no longer assumed the worst. Evidently the recovery had been for his benefit alone, another testament to Booth's acting caliber.

Booth refused to be reasoned with. Flynn's heart sunk when he started going on about Conway—he too knew Conway's fate and its corrosive effect on Booth. "I have a message for Conway," Booth shouted. "I just want to be with Conway," he yelled before letting go of the railing and plunging into the ocean.

The captain barked out a string of orders. The crew flew into action, a safety buoy was thrown over and a lifeboat was lowered. They rowed out in rescue, joined by Flynn. Booth was found a half-mile from the *Neptune*, treading water. The oars were set aside to drag the soaked actor to safety. As he was pulled into the lifeboat, Booth chastised them to be careful or they would capsize

Charles Fraser sketch of Charleston waterfront. A similar view would have greeted Junius Booth when he arrived in Charleston in 1838. *From the collections of the SCHS.*

and "all be drowned"—evidently the urge to commune with the departed Conway, or to duplicate his demise, had passed.

Booth was restored to the ship, dried off and disembarked in Charleston with the other passengers. Little attention seems to have been paid to this strange episode. After all, this was the mad tragedian of the nineteenth century himself, the world-renowned Junius Brutus Booth, an actor famed not only for his craft but also for his unusual behavior. He had spent time in jail cells in numerous cities for disorderly conduct.

After losing several of his children to illness, he reportedly attacked their graves with an axe, reducing the marble tombstones to bits. In a rage, he wrote a letter to President Andrew Jackson threatening to "cut your throat whilst you are sleeping," unless he pardoned two men awaiting the gallows. Jackson was a friend of his.

Upon arriving in Charleston, Booth and Flynn decided it was best to focus on the business that had brought them here in the first place: theater. Charleston was a city noted for its love of the stage, hosting its first serious work of theater in 1735. By the late eighteenth and early nineteenth centuries the city had evolved into the major theatrical center of the South, and one of the top four in

Edwin Booth, brother of John Wilkes Booth and son of Junius Booth, was often regarded as the most talented actor of the family. Many thought Edwin would be the most famous Booth. *Courtesy Library of Congress.*

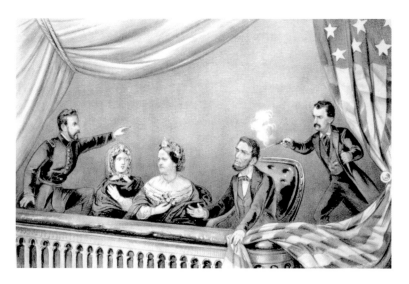

Engraving depicting assassination of Abraham Lincoln at Ford's Theatre, April 14, 1865. *Courtesy of Library of Congress.*

the nation. Just a year earlier, in 1837, the New Charleston Theater had opened on Meeting Street.

Booth and his compatriots were scheduled to open at this venue the next night, but the event was canceled. There are several versions of the story, but the most widely accepted seems to be that the incident occurred about 1:00 a.m. on March 13 at Charleston's posh Planter's Hotel (present-day Dock Street), where Booth and Flynn shared a room. Booth, without provocation, struck the sleeping Flynn on the head with an andiron, hitting him above the right eye. The injured and terrified Flynn awoke to see Booth raising the weapon for a second blow. Unable to get out of the way in time, he was hit again above the left eye. He called out for help and smashed a pewter pot in Booth's face.

Flynn's cries for help were finally answered and the bleeding Booth was restrained. Again, this behavior was written off as just another of "Booth's strange fits." The productions were put on hold while Booth and Flynn recovered. On March 19, 1838, the *Charleston Mercury* ran the following announcement: "We are most happy to learn that the great tragedian is at large again—sane and regular and that he will appear in the theater tonight." Booth appeared opposite the forgiving Flynn in a number of roles until the company departed at the end of March.

Junius Booth died in 1852, leaving behind a reputation as a talented but deeply troubled actor. Two of Booth's sons would go on to successful careers in this field. Edwin Booth gained national acclaim and performed at the same Charleston Theater as his father in 1854. The youngest of his sons did become popular, but never quite matched the fame of his older brother or late father. That is, until April 14, 1865, when John Wilkes Booth entered Ford's Theatre and shed his career as an actor to assume the mantle of one of the most notorious assassins in history.

OSCEOLA

Seminole Warrior, Casualty of War

Frederick Weedon sighed. The boys were misbehaving again, refusing to settle down for the evening. He went into the study, fetched the jar over his desk and then stomped down the hall. Stepping into the noisy bedroom, he held the jar up for his sons to see. They immediately quieted. This was an old routine; they knew unless they behaved the awful thing would be put on the bedstead to keep them company all night.

Weedon tucked the jar back under his arm, went back into his study and returned it to its shelf. He took a good long look at it. As a doctor and scholar of anatomy, the sight hardly had the same impact on him. Floating inside the jar, cocooned with murky preservative fluid, was a human head. Skin still hung on the skull, giving a picture of the man's appearance when he had been alive. Weedon was still proud of the embalming job he had done all those years ago when he had applied his own unique twist on the undertakers' art to this specimen. Specimen wasn't really the right word for it. He had known this man well, had cut the head away from the cooling corpse with his own two hands; this was Osceola, the Seminole warrior.

Weedon's association with this Native American legend had begun in November of 1837, back when he served as a surgeon at Fort Marion in St. Augustine, Florida. The United States was then engaged in an armed conflict that has come to be called the

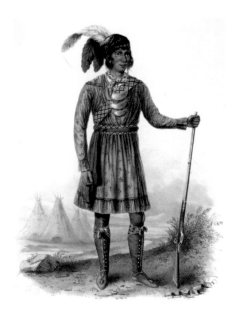

Osceola, Seminole leader and warrior (1804–1838). Based on a painting done by George Catlin, which was made during his captivity in Fort Moultrie. *Courtesy of Library of Congress.*

Second Seminole War. This was sparked when bands of Native Americans, augmented by escaped slaves who were incorporated into the tribes, fiercely resisted the U.S. edict to resettle farther west. After two years of hard fighting in the Florida swamps, the army had made little headway.

Then on October 21, 1837, they netted an important captive. Osceola, one of the most prominent warriors and leaders, was taken prisoner. This should have been cause for celebration, but public opinion decidedly went the other way. There was already much sympathy for the plight of the Seminoles, and their continued resistance seems to have gained them a measure of grudging respect with even their opponents. When the details around Osceola's capture were revealed, they set off a firestorm of criticism.

Osceola had been captured under a white flag. He and his brethren were coming to parley peacefully when they were surrounded and shackled. Safety under the white flag was one of the oldest tenets of the rules of engagement; breaking it was not "civilized warfare." Major General Thomas Jesup, the army official

Thousands of South Carolinians served during the Seminole Wars. This hand-colored lithograph shows South Carolina soldiers along the Withlacoochee River during the Second Seminole War. *Courtesy of Library of Congress.*

There were three Seminole Wars, each one bringing the United States into a brutal conflict with the Indian tribes in Florida. Hundreds of lives were lost and millions of dollars worth of property were destroyed. *Courtesy of Library of Congress.*

responsible for executing the war, had given the order to capture. Jesup's and his subordinates' names were maligned in countless editorials and letters. Jesup defended his actions by stating that the Native Americans had broken numerous promises to them and had themselves abused the flag of truce.

To relieve overcrowding, Osceola and 236 other Seminole POWs were shipped to Fort Moultrie in January of 1838. The January 3, 1838 edition of the *Charleston Courier* ran a headline that read "Arrival of the Indian Chiefs & Warriors," and noted that their behavior while being transferred was "distinguished by good order and sobriety."

Dr. Weedon came with the Seminoles. He had ministered to Osceola and many of the captives in Fort Marion, and was regarded as a trusted liaison. As Fort Moultrie was on an island with few access points, the Seminoles were given the freedom to walk around in the fort during the day. They became instant celebrities. Many Charleston residents boated over to Sullivan's to see firsthand the Seminoles they had been reading about in the newspapers the past few years. None were as popular as Osceola. He had a constant stream of visitors. Several times he was asked to sit for paintings.

Winthrop Williams wrote of his experience with Osecola in a January 6, 1838 letter: "Today being Saturday I took leave of the city and embarked…for Sullivan's Island…visited Fort Moultrie… Oseloa was the one I was most curious to see. He is about 35 years old, large sized, about 6 feet high, well formed, has every appearance of the Indian…has an intelligent countenance, with a sad expression. He is now in rather bad health."

Less than a week after arrival, Osceola and a delegation of Seminoles were allowed to leave Fort Moultrie and go into Charleston. Under guard, they attended the play *Honey—Moon* at the Merchant's Theater. An eyewitness account stated the place was packed. Normally the beautiful actress Miss Cooper, playing the role of Juliana, would have been the star attraction, but she could not compete with the Seminoles. Everyone wanted to get a look at the Seminoles, especially Osceola.

The author of *Osceola, or Fact and Fiction*, identified only as a "Southerner," was in attendance the night the Seminoles visited the theater. The postscript to this biography is a poem, written as a stirring tribute to Osceola.

Osceola at the Charleston Theatre
The chandeliers sent forth a dazzling light,
And splendid lamps and paintings shone around;
The scenery was superb, and all look'd bright,
While not one single seat could there be found.
Indeed, a prince of high pretensions might
Have view'd the scene, and never once have frown'd;
For beauty, fashion, learning, all combined
To form a crowd, genteel, polite, refined.

Then Osceola with his warriors came,
A stern, unbending, stoic band they were,
Whose names, in truth, "will long be known to fame,"
For deeds of valour, and for love of war;
With earrings, trinkets, necklaces, and bands,
Heads deck'd with feathers, rings upon their hands;
A group so wild, grotesque, and yet so sage,
Have very seldom look'd upon the stage.

I mark'd the gloomy thought upon his brow,
Which clung like mist around the mountain's top,
And watch'd his listless mien and careless bow,
As though he saw the play, but heard it not.
And then his lips would breathe some secret vow
To strike for injuries ne'er to be forgot,
And peril all, though life should be the cost,
To save his native home and country lost.
The lovely glow of Juliana's face,
Her smiles and blushes, and the tears she shed,
Her splendid attitude and native grace,
Were to his war-lit spirit stale and dead.

Yes, there he sat, subdued, but still enraged;
Like the fierce tiger, when he's caught and caged,
Will lie composed; yet, when you pass him by,
You'll see a demon spirit in his eye.
The softest strains of music fell unheard,
And every sound seem'd lost upon his ear,
And song that spoke of love in every word,
Nor made him sigh, nor smile, nor drop a tear;
For his wild thoughts, like some unfetter'd bird,
Flew swift as lightning to that home too dear,
Where his undaunted host still long'd to go,
To raise the savage yell, and fight the foe.

Winthrop Williams's initial assessment of Osceola was accurate: Osceola was gravely ill. Despite Dr. Weedon's constant attention, his physical condition rapidly deteriorated. Before being transferred to Charleston, Osceola had been a prisoner under much different conditions, in a damp jail in St. Augustine. Its effects lingered even after he was transferred to Charleston. Dr. Weedon found Osceola suddenly stubbornly resistant to his medicinal cures. On January 26, he suffered from a "violent quinsy," which would be diagnosed today as tonsillitis complicated by abscess.

In his diary, Dr. Weedon documented Osceola's last hours, and the reason of Osceola's refusal of his treatment:

January 29. Oceola is yet ill, one of their prophets Instilld into his mind that he would die if a white man approached him—he would take nothing but what the prophet gave him…about 4 o' clock Oceola sent for me & expressed regret that he had suffered his family to prevail on him to take the prophets medicine saying he knew I was his friend & had saved his life at Fort Marion, but he was unwilling to induce the Indians to believe he had any confidence in a white man, added to this, said he had no wish to live, knowing he would go west…asked as a favor that his bones should be permitted to remain in peace and that I should take them to Florida and place them where I Knew they would

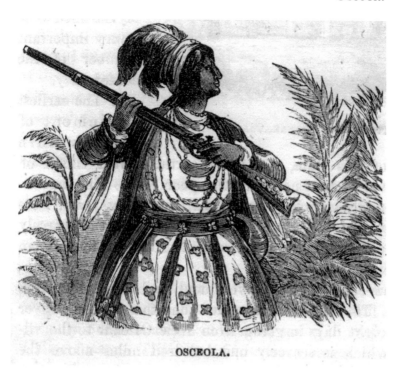

OSCEOLA.

Osceola's actions and subsequent capture propelled him to international fame in 1837–38. *www.Archive.org.*

not be disturbed—here he regretted his country had been taken from him & his people natural Birth right had been wrested from them by the strong & oppressive hand of the white people & if he wished to live, it was only to show them that an Indian never forgot an injury.

At 6:20 a.m. on January 30, 1838, Osceola passed away. He was given a military funeral with all the honors, and laid to rest on the grounds of Fort Moultrie. Judging by the tone of his diary entries, Weedon had clearly come to regard Osceola as a friend. Yet he did not carry out Osceola's last request. In all fairness, he may not have had sufficient pull to arrange the repatriation of such a controversial figure.

Grave of Osceola on the grounds of Fort Moultrie on Sullivan's Island. The marker was inscribed "Oceola," one of the many spellings of the Seminole's name. *www.Archive.org.*

Perhaps it was because of his passion for anatomy and phrenology that he did what he did next, or it could have simply been greed. The night before Osceola was laid to rest, Weedon removed Osceola's head from his body. The corpse was returned to the coffin quietly. The details of this highly unorthodox burial were kept secret from Osceola's fellow Seminoles and family. It wasn't until later that Weedon's actions became known to the public.

That Weedon took the head is a fact. In January 1966, Osceola's gravesite was vandalized, and claims surfaced that the body had been removed to Florida. When a full archaeological dig was done on the site, a headless skeleton, clearly that of Osceola, was unearthed. What became of the head afterward has become more legend. Author Patricia R. Wickman conducted oral interviews with Weedon's descendants for her book *Osceola's Legacy.* The great-great-grandchildren told Wickman of the family stories of how Weedon would put the head in the window of the drugstore he owned in St. Augustine after leaving the army, and how he would use it to frighten his sons into behaving. Four and half

years after Weedon's death, Osceola's head was sent to a Dr. Mott in New York at Fourth Street Medical College. A fire in 1865 destroyed the college, and it was thought Osceola's head was lost in the fire. Still, stories circulate of the intact head having survived and remaining in some private collection.

Starting in the 1930s, Seminoles and Floridians petitioned for the return of Osceola's body. The issue was heated; both sides exchanged volleys for decades on the merits of keeping him where he was and moving him back to Florida as he had wished. In the end, Osceola has remained at Fort Moultrie under the watch of the National Park Service.

Wickman summed up this debate in an article written for a Seminole newspaper: "Some Seminoles, once again caught in the crossfire, got no satisfaction either, but most understand that, traditionally, he should not be brought back until his head and body are reunited."

THE STRANGE AFTERLIFE OF
JOHN C. CALHOUN

In the early morning of April 25, 1850, the signal gun out in the harbor boomed. In Charleston there were many in earshot who were greatly affected by this noise. They stopped what they had been doing; some instinctively removed their hats, and a few of the more emotional started to cry. For close to a month they had been waiting for that noise. It announced the approach of the mortal remains of one of Charleston's most famous and cherished citizens, John C. Calhoun.

This former congressman, secretary of war, vice president, and U.S. senator passed away in Washington, D.C., on Sunday morning, March 31. The telegraph wires started buzzing immediately, broadcasting the news all over the country. During nearly four decades of public service, Calhoun's politics had often made national headlines. This guaranteed that practically every major paper in the country would publish an obituary, as well as quite a few letters and editorials extolling his virtues and lamenting his passing.

As befitting a senator, he was laid to rest in the Congressional burial ground with full honors, with Daniel Webster and Henry Clay serving as pallbearers. This would only be a temporary arrangement. Calhoun wished for his body to be returned to his native state, South Carolina, to Charleston, the city he had always held so dear. On April 22, the metallic coffin holding his body was loaded on the steamer *Nina*. Several stops were made along the way

William Hill engraving of Charleston waterfront, circa 1851. *www.Archive.org.*

in Fredericksburg, Richmond and Wilmington for ceremonies or delegations of mourners to pay their respects. In Richmond, an honor guard of twenty-five South Carolinians joined the procession, tasked with escorting Calhoun the rest of the way.

Spying the flag of the *Nina*, the gunner in Charleston touched off the fuse, igniting the signal gun. Now John C. Calhoun would be buried a second time. The funeral the next day was a grand affair. Tens of thousands lined the streets to watch the pallbearers, governors and ex-governors of South Carolina, carry Calhoun to the western graveyard of St. Philip's Church. Charleston had not had time to erect a monument suited to such a distinguished statesman. His tomb was a simple marble slab inscribed only with a single word: "Calhoun."

It was never intended for this to be his final resting place. Before a more elaborate tomb could be erected, the secession crisis and then the Civil War—or in the words of the state, "public disabilities"—occupied the attention of the public. Charleston was blockaded and besieged in the war. By 1863, it had become clear that there was a chance Charleston could be captured. Charleston tour guide lore holds that there were murmurings from angry Union soldiers who blamed Calhoun's rhetoric for the bloodshed. As vengeance they

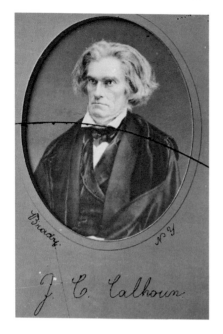

John C. Calhoun (1782–1850).
Courtesy of Library of Congress.

planned to dig him up when the city fell; his skull would be a nice trophy for Mr. Lincoln. Whether true or not, there was enough of a concern as the shells rained down to move Calhoun's body to a secret plot in the eastern graveyard across Church Street.

Charleston did fall in February of 1865. Four years of hard war left it a burned, shelled-out wreck. Union sightseers flooded the ruined city to survey the damage with their own eyes, to stand in the "Cradle of Secession." A pilgrimage to Calhoun's grave was a popular part of the tour. The precaution of the secret grave and empty tomb was not needed. No one tried to exhume Calhoun; the worst seems to have been insults and mocking comments, like that described by a Mr. Cuyler:

> *I stood with Ward Beecher, Garrison, George Thompson, the English Reformer, and Theodore Tilton, beside the grave of John C. Calhoun, in St. Phillip's Churchyard. It is a plain brick oblong tomb, covered with a marble slab, and bearing the single*

The first grave of John C. Calhoun at St. Philip's Church in Charleston. *Courtesy of Library of Congress.*

word "CALHOUN." "There," said Garrison, "lies a man whose name is decayed worse than his mouldering form; the one may have a resurrection, the other never!" Several northern shells, have fallen and burst near that tomb! Did none of the bones in that sepulcher rattle, when the voice of William Lloyd Garrison, was heard at the grave's mouth?

Charleston began the long, costly process of rebuilding. Returning Calhoun to his rightful spot was part of the recovery

process. Mr. Jno. N. Gregg, a sexton of St. Philip's, recalled in 1871, "The late Commodore Ingraham requested me to show where the body was—this I did—then I was employed to disinter the remains and replace them in the original tomb." Calhoun crossed Church Street to the western graveyard yet again on April 7, 1871. This move was responsible for the local quip "John C. Calhoun, he crossed this street more times dead than alive."

Calhoun's eternal rest was cut short yet again. In 1883, a joint resolution appropriating funds for "the construction and erection of a sarcophagus for the remains of John C. Calhoun" passed. In 1884, his body was reinterred in the new, grander tomb. The old marble slab that had covered his grave for thirty-four years was placed in the south wall of the eastern graveyard near the spot where his body was hidden in 1863.

It should have ended there. In February 1965, Reverend Canon Samuel T. Cobb at St. Philip's got a strange telephone call. The man on the other end told him that he was breaking his vow of secrecy by talking to him, but felt he must come clean. He told Reverend Cobb that Calhoun's body was no longer in his tomb. An organization called STORCH, of which he was a part, had whisked away the remains in the middle of the night and reburied them at Fort Hill.

STORCH was actually the Society to Return Calhoun Home. Their manifesto was straightforward. They wanted Calhoun buried at his home at Fort Hill, now part of Clemson University. According to STORCH, this had been Calhoun's wish all along; it was even cited in his will. It was true that Calhoun had remarked while alive that he wanted to be buried at Fort Hill, and a plot was even laid out for him. However, he did not leave a will behind and nothing was committed to paper. Calhoun's widow acquiesced to the argument that Fort Hill was too remote for many people to visit, and conceded that Charleston was better suited for the resting place of someone with such national fame.

A complete investigation of the grounds of St. Philip's proved that the story was false. In 1985, Charleston reporter Jack Leland received a communiqué from a STORCH member restating the

Final resting place of John C. Calhoun. *Courtesy of Library of Congress.*

claim. A quick check showed that nothing was amiss. Although frequently visited, Calhoun continues to, finally, rest in peace.

The Calhoun Monument

Twelve women founded the Ladies Calhoun Monument Association in 1854, desiring to honor the memory of John C. Calhoun. By 1858, the organization had raised enough money to lay the cornerstone of a Calhoun statue in present-day Marion Square in Charleston. The date chosen for the groundbreaking was significant: June 28, Carolina Day. This was the day of the first decisive victory in the American Revolution, when Fort Moultrie had turned away the British armada in 1776.

The Civil War interrupted the erection of the monument and the project was not officially exhibited until 1887. This statue was raised slightly above ground level and was accompanied by a female allegorical statute. Four of these flanking statues were planned, but only one was constructed, causing some to label the monument

The first monument to Calhoun, erected in 1887, was removed in 1895 because of its general unpopularity. *From the collections of the SCHS.*

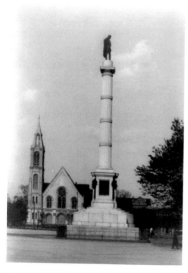

Modern Calhoun monument found in Marion Square in downtown Charleston, just off the street that bears his name. *Courtesy of Library of Congress.*

"Calhoun and his wife." The statue was not popular with Charleston's African American citizens, as Calhoun had been a staunch defender of slavery. There were numerous cases of the statue being pelted with fruit or rocks. One man was caught breaking off a finger.

The members of the association were unhappy with the monument too, but for different reasons. They found much fault in the quality of the construction. It was decided to start over, and the monument was pulled down in 1895, leading a local writer to remark, "The old statue which has so long been a thorn in the side of the ladies of the Calhoun Assn. to say nothing of the general public, will be taken down and consigned to oblivion." The writer went on to state that some people suggested placing the unloved statue over the grave of its sculptor as *his* eternal monument, but such a punishment was too severe.

On June 27, 1896, the second statue was dedicated. This was done quietly, with far less fanfare. This newest incarnation still stands in Marion Square atop an eighty-foot vantage point.

Secession, 1860

It was just after 9:00 p.m. on December 20, 1860, and church bells all over the city were ringing furiously. On another day, at this time of night, the noise might have been unwelcome. Bells sounding after dark usually meant a fire had been spotted or an enemy was at the borders. No one feared such disasters this evening, however; the bells were simply another part of the celebration. The delegates of the Secession Convention had finished. Now South Carolina, especially Charleston, would be immortalized. They had done it; the Union was dissolved!

The average citizen who braved the streets that night would have walked through a scene worthy of a circus; there was something to assault the senses everywhere. As he walked, the seemingly ever-present pealing church bells, the congregations not quite in synchronicity with each other, would have provided the background noise to his footsteps. He would have no problem seeing on this excursion. Lighting the way were the normal iron gas lamps. Tonight their radiance was amplified by the rows of candles and lanterns shining from the windows of the homes and businesses. Smoke hung in the air. Bonfires burned from several different points, each attracting a moth-like swarm of excited people.

Some of the faces passed on the street or clustered around the fires were familiar to our citizen, while others were strangers who had wandered in from the country. Reminiscent of Palm Sunday,

many carried in triumph fronds from the palmetto tree; as residents of the Palmetto State, Carolinians were proud of this symbol. If a complete circuit was made, our citizen would also have seen another important South Carolina symbol on display. Bales of cotton, the major source of economic wealth for the state, were suspended from ropes stretched from house to house, on one of which was inscribed, "The World Wants It."

Fireworks peppered the sky overhead, their sharp black powder popping in balls of multicolored lights. Strings of the earthbound variety, lit by groups of boys giddy at being awake and loose at such an hour, exploded on the streets below. Patrons of taverns, which were experiencing record business, spilled out of their watering holes, adding their tipsy huzzahs to the night air. A few of the more rambunctious sort contributed to the pyrotechnic display with the muzzle flash of pistols or firearms discharged skyward in glee.

In many places our citizen would have bumped into someone he knew, but probably would not have been able to do more than shake hands and smile before moving on, normal conversation being impossible. No one wanted to talk in a mundane manner in a mundane volume anyway on such a momentous day.

Besides the fireworks, shouting, gunshots and all the bells, bands were also in high demand this evening. Playing the "Marseillaise," the musicians strutted about the city trailing a impromptu parade of tramping patriots behind. They marched to the homes of the most prominent men in the city, refusing to leave until treated with a rousing speech. Our citizen may have stopped to listen to one, straining to hear the fiery invocation with everyone else.

Not to be outdone, the militia companies gathered as well. Anyone who owned a uniform trotted it out for the occasion. These soldiers, many far too old for active service, marched in formation, maneuvered in textbook fashion to the cheers of a city that seemed to have become one vast enthusiastic mob. Cannons were fired in salute of this great event throughout the night.

Only three days earlier, this would have been Columbia and not Charleston. The 169 delegates, representing all sections of the state, had assembled in the capital city to discuss the foremost issue of the

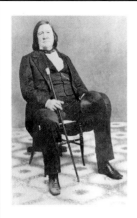

Lawyer and politician James Louis Petigru was part of the minority that mourned South Carolina's break with the United States. He continued to live in Charleston and remained a staunch Unionist until his death in May of 1863. He was present during the Secession Convention and several famous quotes, some likely apocryphal, have been attributed to him. The Honorable J.D. Pope relates the following:

It will be remembered that the Convention adjourned from Columbia to Charleston and sat in St. Andrew's Hall. On the morning of the passage of the Ordinance of Secession I was going down Broad Street and saw Mr. Petigru coming up towards me. We approached each other at the City Hall, and just at that moment the bells of the city pealed forth in gladsome and general unison. Mr. Petigru rushed up and exclaimed:

James Louis Petigru
(1789–1863).
www.Archive.org.

"Where's the fire?" I said: "Mr. Petigru, there is no fire; those are the joy bells ringing in honor of the passage of the Ordinance of Secession." He turned instantly and said, "I tell you there is a fire; they have this day set a blazing torch to the temple of constitutional liberty and, please God, we shall have no more peace forever." In an instant he turned and was gone.

Another account stated that Petigru claimed that the day before secession was the "last happy day of his life." He confided in a friend that he "saw in the secession vote an awful foreboding of what is to come when the passions of the mob are let loose. His beloved South Carolina, he sighed, was too small to be an [independent] republic and too large to be an insane asylum."

day: secession. For the last several decades this political separation had been considered, debated and nearly tried. After the election of Lincoln to the highest office in the land in November 1860, South Carolina determined it was time to take a fresh look at an ordinance that would sever South Carolina's ties with the United States.

Smallpox robbed Columbia of its chance to host the delegates. With cases of this highly contagious disease reported in that city, it was determined to relocate to Charleston. Charleston, of course, was thrilled to serve as host to such a distinguished group. Numerous homemade banners appeared in town, hanging from windows

Citizens flew banners and flags promoting secession during the convention. This banner hung at the corner of Broad and Meeting Streets and was chosen to hang over the desk as the delegates signed the Ordinance of Secession. It is now on display by the South Carolina Historical Society in the Fireproof Building. *From the collections of the SCHS.*

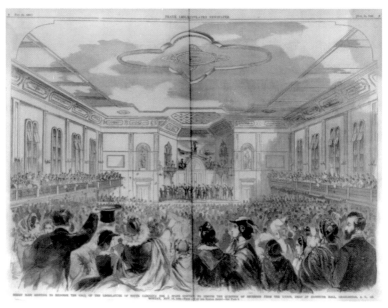

Image of the Secession Convention, December 20, 1860. *Courtesy of Library of Congress.*

and street corners. They proclaimed support for the decision they counted on the delegates to make.

The December 21 edition of the *Charleston Mercury* carried a description of the proceedings:

> *Just before one o'clock, p.m., the Ordinance of Secession was presented by the Committee on "the Ordinance," to the Convention of the people of South Carolina. Precisely at seven minutes after one o'clock, the vote was taken upon the Ordinance—each man's name being called in order. As name by name fell upon the ear of the silent assembly, the brief sound was echoed back, without one solitary exception in that whole grave body—Aye!*
>
> *The Convention sat with closed doors. But upon the announcement outside, and upon the Mercury bulletin board, that South Carolina was no longer a member of the Federal Union, loud shouts of joy rent the air.*

It was decided that the ceremony of the delegates signing their names and affixing the state seal to the document should be a public affair. Their current location was too small to hold more than a token audience. Institute Hall, the site of numerous fairs, bazaars and just recently the failed Democratic National Convention, was chosen as the site. The Secession Convention adjourned until six thirty that evening, reassembling at St. Andrews Hall. Fifteen minutes later, they formed in procession and moved in silence to Institute Hall, forever known after as Secession Hall.

Three thousand people filled the hall to overflowing, and many more stood outside the doors and down Meeting Street, eager to be part of history. Inside, the proceedings began as Reverend Bachman raised his hands and prayed. The audience stood on their feet as one, hats off, eyes closed, hanging on his every word as he asked for divine blessing and favor of what they were about to do. After the chorus of Amens, the Ordinance of Secession was laid across a table and the seal of South Carolina was attached.

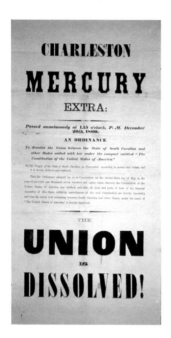

CHARLESTON

MERCURY

EXTRA:

Passed unanimously at 1.15 o'clock, P.M. December 20th, 1860.

AN ORDINANCE

To dissolve the Union between the State of South Carolina and other States united with her under the compact entitled "The Constitution of the United States of America."

THE

UNION

IS

DISSOLVED!

Left: Triumphant broadsides like these littered Charleston after the secession was declared. *Courtesy of Library of Congress.*

Below: View of Institute Hall in 1860, known as Secession Hall after the ordinance was signed. It was burned in the 1861 fire, and has been rebuilt to resemble its original exterior appearance. The interior serves as bank and law offices. *Courtesy of Library of Congress.*

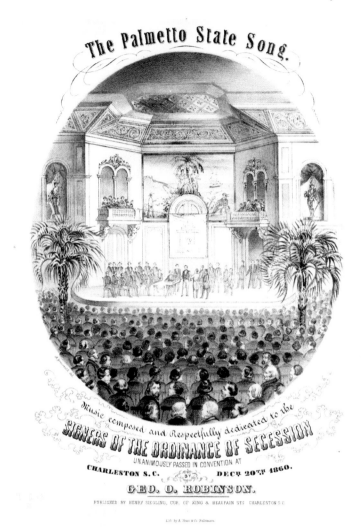

"The Palmetto State Song," a piece of sheet music written to honor South Carolina's withdrawal from the Union. *Courtesy of Library of Congress.*

In a loud booming voice, the president of the convention read aloud the text of the ordinance, slowly and solemnly. When he uttered the last word, "dissolved," the assembled crowd was on its feet again shouting and cheering. When the clamor subsided minutes later, the delegates were called forward to sign. This took nearly two hours.

The *Mercury* recorded the end of this ceremony: "At the close of the signatures the President, advancing to the front of the platform, announced that the Seal of the State had been set, the signatures of the Convention put to the Ordinance, and he thereby proclaimed the State of South Carolina a separate, independent nation."

Then the festivities began. For many fire-eaters, Christmas had come early that year; they drifted into December 25 still in a euphoric haze. To be sure, there was still the matter of the Federal military installations around Charleston. There was Castle Pinckney, Fort Johnson, Major Robert Anderson's small garrison, now foreign soldiers inside Fort Moultrie and of course the unfinished fort in the mouth of Charleston Harbor, Fort Sumter. The Federals' return to South Carolina had yet to be successfully addressed. These were matters for the politicians to sort out—not the soldiers, our citizen assured himself.

In the quiet, still hours on the day after Christmas, Major Anderson abandoned Fort Moultrie on Sullivan's Island for the more defensible Fort Sumter. On April 12, 1861, the first shots were fired upon that fort, triggering a war that would claim 620,000 American lives—more than the Revolution, World War I, World War II, the Korean War, the Vietnam War, the Gulf War and any of the modern conflicts combined.

TO TAKE CHARLESTON

The Battle of Secessionville

Gettysburg. Antietam. Bull Run. These are names that even those who are only faintly familiar with the Civil War recognize. U.S. history books exhort these battles as pivotal turning points, numerous scholarly works have dissected their importance and meaning and great parks have been erected to commemorate the grounds where these conflicts took place. One estimate suggests that over ten thousand battles of varying degrees of size and severity took place between the Union and Confederate forces between the years of 1861 and 1865. Unfortunately, the historical and human importance of many of the "smaller" conflicts is often overshadowed by the horrific tragedies of the "larger" ones.

In the Lowcountry there is such a place. Just a few miles across the harbor, nestled in the heart of a residential neighborhood on James Island, is the site of Fort Lamar, a key feature in the Battle of Secessionville. Locally, the battle is well known. Although a modern road has split the remnants of Fort Lamar in two, the halves have been lovingly conserved by the Department of Natural Resources and a dedicated group of volunteers who assemble regularly to clean and maintain the area. Self-guided tours of the location are available year-round via a free pamphlet containing a map and basic overview of the battle. Annually on the grounds of Boone Hall Plantation in Mount Pleasant, reeneactors restage the battle

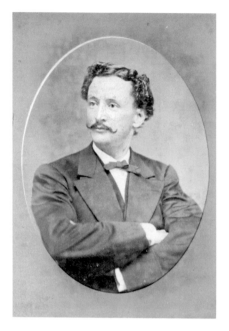

Augustine Thomas "Gus" Smythe (1842–1914), Confederate soldier and signalman who wrote of his personal experiences of June 16, 1862. *From the collections of the SCHS.*

for curious spectators over the course of a weekend. However, on a national level the battle remains relatively obscure. In the words of one historian, "The Battle of Secessionville has been shamefully slighted by the compilers of history."

"We have been in our first fight & have met the Yankees at last," Confederate soldier Augustine Smythe wrote on June 17, 1862. "Have met the Yankees at last"; this sentiment of released tension was shared not just by Smythe's brothers-in-arms but also accurately described the disposition of an entire city. Since the Fort Sumter crisis, Charleston had been holding its collective breath, waiting for the hammer to fall.

It was widely broadcast that a majority of the Northern supporters of Lincoln and the Union believed South Carolina, especially Charleston, was responsible for causing the war. South Carolina was the first state to go out of the Union, at a convention held in Charleston. It was also the authorities in Charleston who ousted Major Anderson from Fort Sumter in

April of 1861, which really ignited the Civil War. Both sides knew that as a port city and as a symbol of the Confederacy, Charleston was going to be strategically important.

In anticipation, the Confederates dug in, ringing Charleston with a series of elaborate defensive works. As Charleston entrenched itself, the Yankees made their first feint. At the close of 1861, Port Royal Sound, less than one hundred miles away, was overrun, swallowed by the navy. With this section of the coast under their jurisdiction, the blockaders, steamships forcibly turning away Southern shipping, now had a station. Their numbers began to rise. Things began to get tight in the city, but captains willing to run the blockade could still be counted on. A month later the blockaders scuttled a fleet of old whaling ships loaded with stones at the mouth of Charleston Harbor, attempting to close the port. It closed one path out, further limiting traffic.

Then, in early June of 1862, the main blow arrived. Federal soldiers began landing on James Island. Rather than tackle the obstructions head-on, they decided to use the back door, the same path the British had taken in 1780 that had ultimately resulted in the capitulation of Charleston. Conscious of such a possibility, a line of defensive works stitched their way across the island, although shortages of manpower dictated they be manned by little more than a skeleton crew.

The close proximity of the Federals greatly alarmed the citizens in Charleston. "People are moving in crowds from the city. Carts are passing at all hours filled with furniture." The bells of St. Michael's Church, the oldest church in the city, had been stolen during the British occupation of 1780–82. They had later been returned by a British merchant, perhaps concerned about his spiritual well-being, to the congregation. Unwilling to tempt fate a second time, the bells were hauled down and sent to Columbia to keep them out of harm's way.

The Federal invasion operation was under the command of General Hunter and his subordinate General Benham. By June 11, the forces of these two had come up stout against the Secessionville section of the defensive line. Ironically enough,

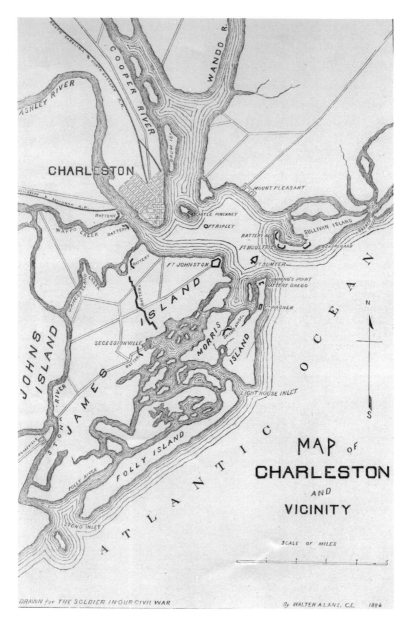

Map of Charleston showing forts and defensive works, 1861. *Courtesy of Library of Congress.*

Secessionville's name had nothing to do with the Southern states' secession; it refers to an earlier event in which a group of younger planters "seceded" from an area occupied by their elders. Fronting this small community was an unnamed, unfinished fort built in the shape of a slightly skewed *M*. A wooden observation tower several stories high stood directly behind it. The presence of this structure caused the fort to be referred to as Tower Battery.

General Hunter felt he had pressing business back in Hilton Head and prepared to leave. Before departing, he ordered Benham not to attack unless threatened. Benham exploited that clause to mount an assault. On the morning of June 16 he decided to make a "reconnaissance in force" against the Tower Battery. His advance troops in the attack had a euphemism for his plan: "a forlorn hope."

Like Confederate defenses everywhere, the Tower Battery was thinly manned and incomplete. Sensing an impending assault, the short-staffed crews had labored around the clock to get the fort into a better fighting condition. Most of those inside the fort had been asleep only a short while when the attack came. Over the course of the day, Benham would throw well over four thousand men at the position. Reinforcements were desperately needed to keep possession of the fort.

The Confederates were also hindered by a dissension among their leaders. George Nathan

A soldier of the Union. *www.Archive. org.*

General Nathan "Shanks" Evans (1824–1868), South Carolina native and West Point graduate. Evans was newly promoted and in charge of the Confederates at the Battle of Secessionville. Regarded as a hero of Manassas and Ball's Bluff, Evans put in a questionable performance at Secessionville that has become a matter of controversy. *www. Archive.org.*

"Shanks" Evans, whose performance at the Battles of Manassas and Ball's Bluff had earned him great praise and the rank of general, was accused of negligent command at Secessionville. Lieutenant Colonel Ellison Capers went as far as to write, "Genl. Evans is a coward with a reputation for bravery which he has earned by sending his men and officers where he never dreams of going…He…drinks to excess."

Despite the odds stacked against them, the Union troops executed a gallant attack and the Confederates managed to muster a stubborn defense. Augustine Smythe was part of a unit sent over from Charleston to aid the vastly outnumbered defenders.

Smythe describes his company's rush to meet the Federal attack. "We fell quickly in line, hurried by the sight of the shell bursting round Secessionville. We marched at quick for some time, but as we neared the battle ground, we could stand it no longer…giving a shout, rushed on at double-quick. We turned off thro the road… then thro another field in which the shells were falling." Once

through this dangerous gauntlet and on the field, they were wisely given the order to lie down. "Scarcely were the words uttered... than volley after volley of bullets flew around us, cutting off the branches in front of us." Smythe commented on the behavior of himself and his comrades: "It was a trying moment, for none of us knew but that the next bullet would finish us, yet the men behaved with great coolness, fixing their bayonets and getting ready for the charge."

Even with the additions of Smythe's company, the Federals would maintain superior numbers. Despite this advantage, they were unable to take the fort in the roughly three hours of fighting that followed. They had numerous difficulties maneuvering in the surrounding marsh and coordinating attacks, while the Confederates stubbornly stood their ground and received reinforcements at critical points. Casualty counts vary from report to report. All of them, however, point to a stunning Union defeat. One estimate lists close to seven hundred killed, wounded and missing for the Union, and only two hundred for the Confederates.

Smythe was assigned to a squad to gather up arms and look after the wounded following the fighting. He gives this vivid account of the battle's costly aftermath: "I was sent & such a scene I wish never again to witness. Many were in the water, dead,

Even in 1862, the Confederates were starting to feel the effects of war shortages, which grew more dire as the blockade intensified. Sometimes the only food, money or clothing they could count on was what could be scavenged from their dead Union counterparts. A Confederate solider identified only as Charlie W. wrote on June 19, 1862:

The Battle of Secessionville was quite a severe contest while the fight lasted, full particulars of which you have seen in the papers. I will mention a few things the papers did not. About 5 o'clock in the evening Capt. Buist visited the field...He counted the dead in it, 90 men of whom not a man had on a shoe or boot nor buttons on their coats, as everything of value had been stripped off of them.

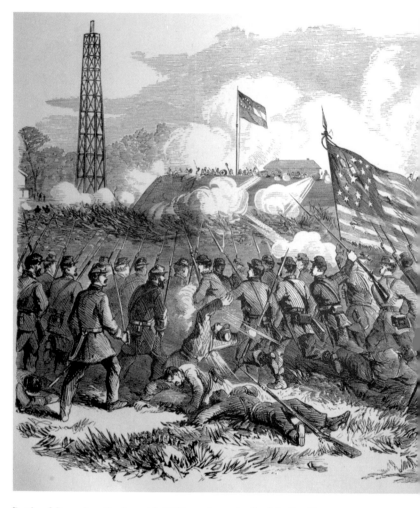

Battle of Secessionville, June 16, 1862, as shown in *Frank Leslie's Illustrated Newspaper. www.Archive.org.*

in a small creek between them & Secessionville, one poor fellow wounded in his back and throat lay in the water close to the bank, but unable to get out while the tide was up to his shoulders and continually rising." Smythe pulled this man to safety and comforted him as best he could. After gazing upon the area where Fort Lamar's artillery had fired into the Union ranks, Smythe remarked,

"On the other side of the marsh…the slaughter…was immensely greater." Casualties from this battle would be found along James Island for a time afterward. Smythe tells how "one poor fellow who had evidently been wounded, had crawled to the edge of the bushes & taken off his clothes…laid them by his side, then folded his hands across his breast & died. Poor fellow, had he been attended to & had

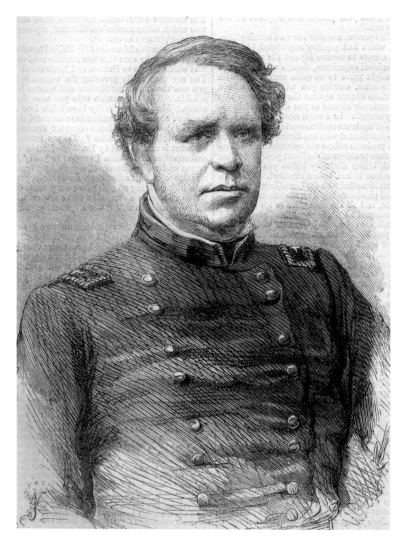

Henry W. Benham (1813–1884). Benham took liberty with his orders from his superior and attacked the Tower Battery. This would lead to court-martial proceedings, but he was eventually exonerated and promoted later in the war. *www.Archive.org.*

Private Philip W. Coleman from the Eighth Michigan Infantry wrote of his being severely wounded at Secessionville, and his harrowing escape from the battlefield:

The charge was made and at the third volley from the enemy's guns I was among those who fell having been wounded by a canister shot in the left arm, left side, and a bullet went in the top of the head, and right thigh, the left arm hanging by the muscles at its back…In order to save my life, the veins and arteries in my arm having been severed by the canister shot, I held the artery of my left arm with the thumb of my right hand and retreated.

Unbelievably, Coleman made it back into his lines and into a hospital and would recover to write about his experience.

food, he might have lived. He must have heard horrible stories of having his clothes torn off him after death & wished not to have his body disturbed.—Awful!"

This victory resulted in court-martial proceedings for General Benham and the withdrawal of Union forces from James Island. Charleston would be spared capture and occupation for a few more years. Although there would be several attempts to take Charleston during the war, Secessionville would never again be the scene of a major battle. Its presence, and the memory of the horrendous defeat suffered there, served as a deterrent to further Federal attacks.

The Tower Battery was finally fully completed in the spring of 1864, and was officially renamed Fort Lamar to honor its commander during the battle, Thomas Gresham Lamar, who had died from illness in late 1862. Fort Lamar was evacuated with the rest of Charleston's Confederate forts in February of 1865 when General Sherman marched from Savannah and into the Carolinas.

Had Secessionville fallen in 1862, little would have stood in the way of Union advance into Charleston. The capture of the city in 1862 might have had far-reaching consequences in the future, possibly shortening or altogether ending the war. Gettysburg. Antietam. Bull Run. Secessionville?

David VERSUS GOLIATH, 1863

Just after nightfall on October 5, 1863, the Confederates undertook a desperate gamble. Despite the danger, the Federal ships surrounding Charleston Harbor had to be contested. For far too long the guns of the blockading squadron had controlled the port, denying access to much-needed supplies.

The mission's success rested on the performance of a new weapon of war, a semi-submersible torpedo boat called the CSS *David*. This engineering marvel was cigar shaped, pointed at each end. It was 48^1/$_5$ feet long, 5 feet in diameter and built from wood. A two-bladed propeller driven by a steam engine could propel the vessel and its four-man crew up to ten knots per hour. At the end of the hollow iron spar projecting fourteen feet in front of the ship sat the *David*'s payload: a copper torpedo packed with about seventy pounds of gunpowder. Tradition holds that the ship was affectionately called the "Little David" because this deadly torpedo was the ship's slingshot.

This *David* had a Goliath to face as well: the USS *New Ironsides*, by most accounts the most heavily armed and formidable vessel that existed in the world at the time. For weeks the *Ironsides* had pummeled the Confederate defenses around Charleston with its powerful arsenal, its thick reinforced hull shrugging off everything thrown at it, inflicting only minor damage.

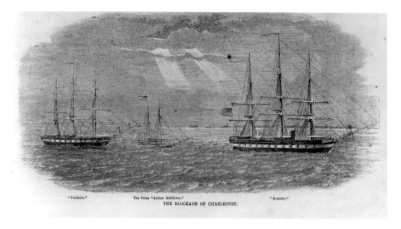

Charleston was subject to a Federal blockade, which prevented supplies from coming in or cotton going out. Unable to develop a navy to challenge the Federals on their own terms, new weapons like the CSS *David* were developed. *www.Archive.org.*

Businessman Theodore D. Stoney had observed firsthand the destructive firepower and seeming invincibility of the *Ironsides*. Using a pair of binoculars, he had watched the vessel trade blows with Battery Wagner. Stoney was so concerned about the threat that he offered $25,000 (close to a quarter-million dollars in today's market) of his own money toward the construction of something that could challenge the *Ironsides*. The Confederates decided, given their limited resources, that a torpedo boat was the best counteroffensive. When word spread of the project, other Charleston businessmen stepped up, and with their financial backing and the work of several skilled engineers and designers the *David* was born. Manufacture and trials of the secret weapon were conducted at the riverfront plantation of Dr. St. Julien Ravenel, one of the designers. Ravenel's property, thirty-four miles north of Charleston, was hoped to be far enough away from the prying eyes of Union spies and sympathizers.

Under the command of Lieutenant Glassell, the *David* slid from its place at the wharf and made its way out to sea. Glassell recalled, "We left Charleston and proceeded with the ebb tide down the

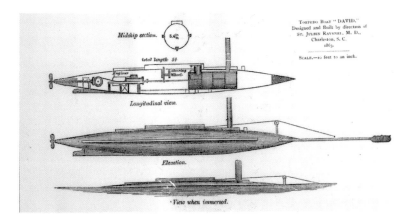

Diagram of the CSS *David*. Torpedo boats were called "one of the most momentous inventions of the Confederacy." *www.Archive.org*.

harbor. A light north wind was blowing, and the night was slightly hazy, but starlight and the water was smooth. I had decided to make the attack about the turn of the tide." The weather only worked in their favor. The torpedo boat was already hard to spot, as it had been painted a concealing faint blue-gray and had a set of ballast tanks that, when filled, allowed it to partially submerge. Only its narrow smokestack and a small section of its upper hull were visible above the waterline.

Using this low visibility to its advantage, the *David* successfully steamed its way out to the *Ironsides*. Lieutenant Glassell sat on the deck out in the open, the ocean on either side of him, dangling his feet inside to work the steering wheel.

> *We passed Fort Sumter…without being discovered. Silently steaming along just inside the bar, I had a good opportunity to reconnoiter the whole fleet of the enemy at anchor…Quietly maneuvering and observing the enemy, I was a half an hour waiting on time and tide. The music of drum and fife had just ceased, and the nine o' clock gun had been fired from the admiral's ship as a signal for all unnecessary lights to be extinguished and for the men not on watch to retire for sleep. I thought the proper time for attack had arrived.*

Glassell yelled down to his crew to bring their craft up to full speed. As the *David* sliced through the water, bearing down on its prey, Glassell reached down to pick up the shotgun loaded with buckshot he had stashed below.

Glassell's record continues:

> *When within about 300 yards of her, a sentinel on board hailed us "Boat ahoy! Boat ahoy!" repeating the hail several times very rapidly…I made no answer, but cocked both barrels of my gun. The Officer of the deck now made his appearance, and loudly demanded "What boat is that?" Not being within forty yards of the ship, and with plenty of headway to carry us on, I thought it about time the fight should commence, and I fired my gun. The officer on deck fell back mortally wounded (poor fellow) and I ordered the engine stopped. The next moment the torpedo struck and the vessel exploded.*

Chief Engineer Tombs gives an account of the impact: "The *David* struck the *Ironsides* about 15 feet on the starboard quarter,

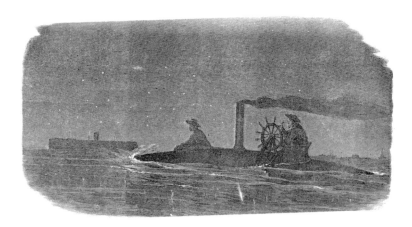

The attack on the USS *New Ironsides* made national news. This engraving comes from an 1863 edition of the New York–based *Harper's Weekly. www.Archive.org*

and the torpedo some 6½ feet below the surface. The *David* was going full speed when she struck, but the engine had just been reversed. The concussion was severe." A column of water 100 feet high erupted as the torpedo burst. A shock wave ran through the *Ironsides*, toppling rigging, dismounting cannons and scattering furniture and sleeping sailors below decks.

The deluge came crashing down into the *David*, flooding the torpedo boat and drenching everything and everybody aboard with frigid water. Glassell was battered, but managed to stay aboard and topside. Within seconds he was shouting for a damage assessment. It was not good. Tombs reported that the fire stoking the engine, an old locomotive drive, was extinguished; they could not move. It looked like the boat had been ruptured too; water seemed to be flooding in.

Thinking the *David* damaged beyond repair, Glassell gave the

Torpedo warfare was in its infancy at the time of the Civil War. In the nomenclature of the nineteenth century, the word "torpedo" was used to describe any sort of buried or submerged explosive. These torpedoes lacked propulsion systems. Detonation occurred when these hidden devices were accidentally struck, or when they were delivered directly to their target via a mechanism such as a spar mounted on a ship. These devices were dubbed "infernal machines" and were frowned upon as an uncivilized means to wage war. Those using this controversial technology knew that they could face harsh repercussions if taken prisoner. This concern was reflected in the postwar memoir of the *David*'s chief engineer, James H. Tombs, regarding the *Ironsides* attack:

When within a short distance, we were hailed from her quarter-deck, and the only reply was from a double barreled shot-gun in the hands of Lieutenant Glassell. He felt that a torpedo attack was an innovation in naval warfare, and that if we did not give warning of our approach, we might, if captured get a short shrift. He thought best to fire, not for the particular intention of killing some on, but for own benefit.

order to abandon ship. Sullivan, the fireman aboard, and Glassell grabbed a cork life preserver and swam toward the blockaders. Tombs realized that the flood had washed away the other life preservers, so he had no choice but to swim. He struck out for Morris Island, where he hoped to be picked up by his side. During

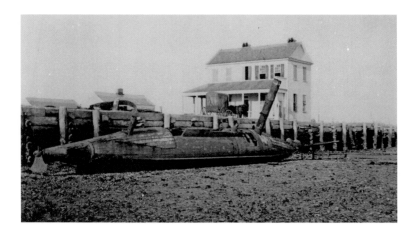

This image taken by Selmar Rush Seibert in 1865, after the fall of Charleston, shows a grounded torpedo boat on Chisolm's Causeway at the foot of present-day Tradd Street. By 1865, there were nearly a dozen *David*s in various stages of completion in the harbor. *Courtesy of Library of Congress.*

Photographer George Cook took this shot in 1864–65 showing a group, primarily composed of children, seated around one of the torpedo boats known as a *David*. By 1864, the term *David* had come to apply to all such vessels and not just the original. *www.Archive.org.*

the swim he looked back to see that remarkably the *David* was still afloat. The water inside was from the explosion, and not from leaks. Deciding to make an attempt to save the boat, and himself from drowning, he turned back. Tombs found that one of the four-man crew had never left. The pilot Cannon could not swim, so instead of bailing out he had stayed aboard clinging to the life lines, hoping to be rescued before sinking.

These two men were able get the *David* started again and started her home. Glassell vividly remembered the scene as he and Cannon "made the turn upstream between the *Ironsides* and a monitor just east of her, and as we turned came almost near enough to the monitor's quarters to touch her. As we headed toward the harbor and through the fleet and guard boats, they all fired wild, for they were about as badly rattled as we were. We passed right between the two guard boats, but for some reason neither fired a shot at us." The *Ironsides* crew recovered enough to fire three shots from its heavy guns out into the water. These also went wide of their mark. "If intended for us, [they] did not come near the *David*," Tombs commented.

The torpedo boat safely returned back to Charleston. Glassell and Fireman Sullivan were pulled from the water by the blockaders and were made prisoners. At first it seemed it had all been in vain. The *Ironsides* kept to its post in the blockade, giving the appearance of business as usual. However, as the crew drew upon the coal in one of the bunkers in the great ship, it became apparent that the torpedo attack had indeed caused serious structural damage. The *Ironsides* was towed to a Federal base in Philadelphia for extensive repairs. For a year the ship lay in dry dock before returning to action. The Union navy tried to keep the exact nature of the damage under wraps, for fear of emboldening the Confederates. Yet those in Charleston noted the sudden disappearance of their powerful adversary and surmised its fate.

David had felled Goliath again. The *Ironsides* never returned to terrorize Charleston Harbor.

THE BATTLE OF HONEY HILL

Upstairs, Agnes Bostick waited in her wedding gown. For hours now, the roar of cannons had marked her patient vigil. There is no account of what Agnes did while she waited for her husband-to-be, whether she paced anxiously or simply sat still. Likely, she did anything that provided distraction from her thoughts. She knew her absent groom was close to these barking guns, directing his men, sharing their danger. Her beloved Charles might be terribly wounded doing his duty, or worse, killed upon the field. What expectant bride in this situation would not be consumed with the fear that she might be widowed before the marriage?

Down below, the guests had all dutifully assembled at the time and place appointed on their invitations. They had gathered for a distraction themselves; a quaint country wedding was just the thing to lighten an otherwise bleak year.

It was November 30, 1864, and the notion of a romantic war had long since faded. There was scarcely a family in South Carolina that had not suffered some personal loss from the Civil War. The realization of a country of their own seemed more unobtainable with each passing month. General Lee and the shrinking Army of Northern Virginia were penned in the trenches of Petersburg by General Grant's ever-swelling Army of the Potomac, the United States Naval blockade of Confederate ports tightened and one

Railroads were considered one of the most valuable military commodities during the Civil War. Several attempts were made by the Federals to sever the line between Charleston and Savannah. *www.Archive.org.*

of the South's prized cities, Atlanta, now rested in the hands of General Sherman.

The sounds of the battle outside seemed almost to mock the wedding party's hope for a joyous interlude. Noticing the growing despondency, one of the group, Nan Desaussure, went up the steps to speak with her sister. She convinced Agnes to change her gown and join the guests below. Trying to salvage what they could, they sat down and ate the wedding feast with the harsh music of battle playing in the background.

Near the planters' village of Grahamville, Agnes's betrothed, Colonel Charles Colcock, had gathered the men of his Third South Carolina Cavalry and whatever able-bodied soldiers were still present in the area at a defensive work known as Honey Hill. With Colcock was Colonel Gonzalez, a Cuban revolutionary, who had married into a Southern family and joined the Confederacy. He would work with Colcock and oversee the artillery around the earthen work of Honey Hill. Providing most of the troops for defense was General G.W. Smith and his men of the Georgia

Militia and the Georgia State Line. Bending to necessity, General Smith allowed his men to cross the borders of their native state, which militia usually declined to do, and fight in South Carolina.

One of the reasons for this breach of military protocol was the precious nature of the threatened point. More than five thousand Federal soldiers under the command of Brigadier General John P. Hatch had been assembled for the purpose of severing the vital South Carolina and Savannah Railroad. Railroads were of great importance to the armies and civilian population during the Civil War, and the South desperately needed to hold onto its dwindling resources in 1864. To sever the rail line near Grahamville, the Federals would first have to break the Confederate resistance at Honey Hill. Charles Colcock was an early investor and pioneer of this very railroad line, having advocated the construction of the Charleston and Savannah Railroad before the start of the Civil War. Now he was defending this project with his life.

Due to numerous logistical problems, the Federals had lost the element of surprise, which gave Smith and Colcock time to line the earthen works two men deep and place Gonzalez's artillery where it would do the most damage. During the fighting, Colcock had overall command, although General Smith officially outranked him. For many long hours, he gave orders, encouraged the men and when he had a quiet moment he must have thought of Agnes waiting for him.

Several costly charges were ordered against the strongly defended walls of Honey Hill. As the fighting went on, the Federal casualties mounted. Bodies literally piled up around the earthen works and in the surrounding swamps. Finally, a withdrawal was ordered and the Federals retreated. Hatch's poor leadership cost the Federals dearly. More than seven hundred men were reported as wounded, missing or killed in action. Months later, Hatch's superior, General William Sherman, visited this battlefield and was heard to remark, "Why didn't you flank them, Hatch?" This maneuver had been tried, but only after large numbers of the rank and file had been sacrificed in frontal charges.

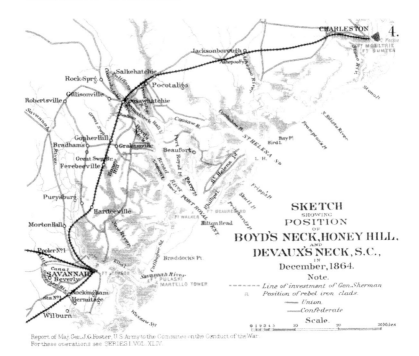

Map showing the Battle of Honey Hill, November 30, 1864. Had the Confederates lost the battle, it could have resulted in the evacuation of Charleston. *Courtesy of Making of America.*

The wedding party dissolved after supper. The occasion was soured, and they had their own loved ones to tend to. Nan Desaussure stayed with her sister. Together, they anxiously waited for word of the fighting and of Charles. At 2:00 a.m., they heard the galloping of horses. A courier had arrived with welcome news: Colonel Colcock had been delayed by the fighting, but was not wounded and would be home as soon as possible.

Two days after this message was delivered, Colcock arrived for his bride, even bringing a minister with him so that the ceremony could be performed immediately. The newlyweds spent a honeymoon determined by necessity. The Army of Northern Virginia was still

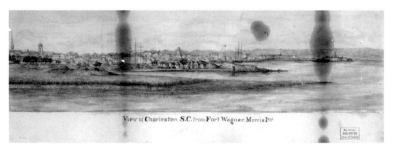

View of Charleston Harbor, circa 1863. Colcock's victory gained Charleston a short respite. Nearly three months later, it was evacuated and occupied by Union Forces, including some of the same units that had been repulsed at Honey Hill. *Courtesy of Library of Congress.*

in Petersburg for a long siege, and General Sherman was marching his army through Georgia, "making it howl," and South Carolina would soon be next. Colonel Colcock brought Agnes with him as he performed his duties; much of their honeymoon was spent within fortifications along the coast.

The couple stayed together through the turbulent closing year of the war. They had three children and by all accounts were happily married. Charles Colcock passed away on October 22, 1891, with his wife Agnes by his side.

Reverend John G. Williams was also present on that fateful day, called to the deathbed to provide comfort and spiritual guidance. He witnessed the final moments of the "Hero of Honey Hill": "His death was a very happy one; while passing through the valley of the shadow of death he asked his wife to sing his favorite hymn, 'Jesus, Lover of my Soul,' which she tried to do, and weak as he was, he tried to join." Agnes Bostick Colcock, described as a beautiful woman with a "voice of a bird," sang her husband into his final rest that day. She never remarried and joined him in death in 1914.

The Fall of Fort Sumter, 1865

At midnight on February 18, 1865, Major Thomas Huguenin walked among the empty ruins of Fort Sumter, making his final inspection. This tour gave him and his two attendants claim to a dubious distinction. They would be the last Confederates to occupy the fort immortalized in history as the birthplace of the Civil War.

The rest of the men waited in a pair of boats, tied off at the rickety wharf adjacent to Sumter. Strange to think that he would never again have to see that the wharf was rebuilt; it had been blown into kindling and hobbled back together again countless times since the bombardments began. By now the departing soldiers had crossed the wharf, boarded the ships and stowed away their bags. Now they were likely trying to find a place to sit topside to smoke and drink a cup of coffee. The veterans looked for a spot to doze.

Transfer meant leaving this difficult place, no more hunkering down in tenuous folds of cracked brick and sand or huddling in the suffocating atmosphere of the bombproof while a seemingly endless succession of shells rained down upon them, no more living on scanty rations and polluted water. Yet Huguenin and many of the garrison did not look forward to leaving. Sumter had become a symbol for the Confederacy; to serve in such a place was an honor. Regardless of personal feelings, the order had to be obeyed; Fort Sumter was to be abandoned and Charleston was to be evacuated.

One of Huguenin's aides held aloft a lantern to light their way as they made a circuit of the interior. The magazine, the mess, the bombproof, the surgeons' makeshift hospital and the officers' quarters were emptied, just as he had ordered. His own room had already been tended to, stripped of all his small personal effects. The official records had been saved, sewn into his spare clothing for protection. The rest was not so fortunate; his collection of books on military history and theory had to be left behind. To deny a Yankee looking to enrich his library, the prized volumes were cooked down to ashes in the fireplace.

In the barracks, the men had made a thorough sweep, taking everything of value, sentimental and material, with them. The only item of note Huguenin found left behind was some whiskey. No doubt there would soon be an angry soldier rooting through his baggage looking for it. Anxious to avoid its disruptive presence, he emptied the bottles into the water at the spot where the Atlantic flowed inland to create the Cooper and Ashley Rivers. The old Charlestonians had always claimed it was the other way around; it was their mighty rivers that went out to form the Atlantic.

Sketch of the ruined interior of Fort Sumter, as drawn by a Confederate officer stationed at that post in 1864. *Courtesy of Library of Congress.*

Fort Sumter, 1865. *Courtesy of Library of Congress.*

After dumping the bottles, Huguenin and his men began their survey of the outer works. Although they had been on duty at the island fort for months, it was still wise to be slow and careful. Knowing every inch of the fort did not guarantee safety. Since the war had begun, tens of thousands of cannonballs, amounting to hundreds of tons of metal, had been hurled at Sumter. The fifty-foot-high walls that once encircled the place were now a skeletal masonry range, splintered into countless jagged pieces of brick. Wicker baskets filled with earth (called gabions) were wedged into these powder-scorched fractures, almost giving the fort the appearance of an earthenwork. Rubble was strewn everywhere. To take a step without something underfoot was a rare occurrence.

Perhaps during his tour Huguenin reflected on just how different a place Sumter was in 1865 than in 1861. That was the year in which another major, his Federal counterpart, Robert Anderson, had held it against overwhelming odds for nearly two days. When Anderson made his stand in 1861, the fort had been incomplete. When he surrendered, he left behind a Sumter damaged by that first intense bombardment, yet still projecting the demeanor of a

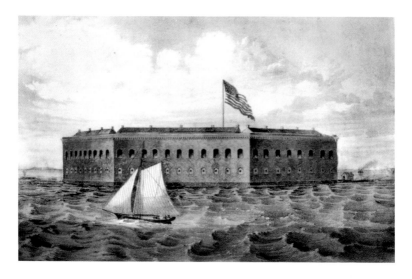

Fort Sumter as it appeared in 1861 before the Civil War. *Courtesy of Library of Congress.*

place that could be the embodiment of military precision—it was simply unfinished. Now it was just finished.

In the close of the Anderson affair, proud Southern rhetoric boasted that the departing soldiers would be the last Federals to hold what rightfully belonged to the South. Earlier today, Sumter's proud flag, riddled from the elements and torn by battle, had been taken down and secured. A stainless doppelganger flew in its place, one never fired upon. Come tomorrow, the United States banner would fly from the flagstaff of Sumter once more. Swarms of men from places like Massachusetts, Pennsylvania, New York and Rhode Island would be sifting through the rubble in search of souvenirs to send home. Roughly a year ago, Sumter had stopped being useful as a gun platform, the majority of its cannons either dismounted or moved off into the interior. Infantry continued to stubbornly protect the post with muskets, grenades and even hurled bricks. Sumter had never lost its political value—all through the Civil War, generals and admirals with ambition planned on how to take and hold Sumter, while Confederates resisted tooth and nail.

The Fall of Fort Sumter, 1865

As the Confederates evacuated Charleston, they fired warehouses filled with cotton, destroyed cannons and detonated munitions stockpiles. The result was a string of fires that further damaged the battered city. *Courtesy of Library of Congress.*

The 1861 fire cut a swath of destruction through Charleston. This accidental fire only highlighted the damage done to Charleston by the shelling and four years of war. This 1865 image shows the ruins of St. Andrews Hall, where the delegates decided upon secession. *Courtesy of Library of Congress.*

One of the greatest tragedies of the evacuation was the explosion of the North Eastern Railroad depot. On February 18, about 150 civilians, men and women of all ages, looking for food inside the depot were killed when a store of nearby gunpowder exploded. Another estimated 250 were injured. *Courtesy of Library of Congress.*

Now that the order to abandon it, to evacuate Charleston altogether, had come down the channels, Huguenin was not the only Confederate who must have wrestled with the feeling that perhaps it had been in vain. General Sherman's sixty-thousand-man juggernaut was plowing across South Carolina, rumored to be in Columbia, threatening to make Charleston an isolated outpost. An evacuation was especially galling because it was not due to a battle lost by their arms, but because of the approach of a distant threat.

Surely Huguenin and his aides found some consolation that at least the fort wasn't under fire at the moment. It was common practice for the hostile coastal lodgments, including Fort Strong (formerly Battery Wagener) and their metal-plated consorts, the monitors, to shell Sumter for hours on end. Tonight, their attention was focused exclusively on Fort Moultrie, their sister fortification to the west on Sullivan's Island. Tonight, Moultrie fired only a few halfhearted shots back in defense. They were preparing to evacuate as well.

The casemates, the sentinels' stations along the crooked parapets and the parade ground were all checked. The inspection finished,

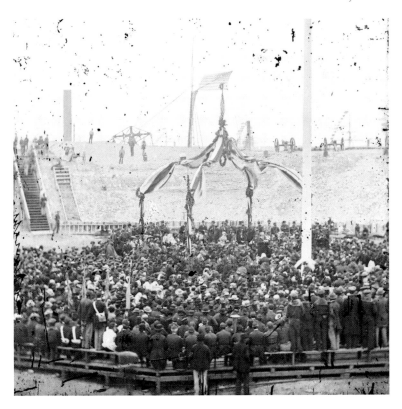

Major Robert Anderson returned to Charleston on April 14, 1865, to raise the American flag once again over Sumter. *Courtesy of Library of Congress.*

they made their way to the idling boats. Soldiers and sailors were topside to greet them, soaking in their last impressions of Sumter. Once aboard, Huguenin personally cast off the mooring lines. The anchors were ordered up and the ships sped away. In a later reminiscence, Huguenin described these last few moments in Sumter:

> *After visiting every portion of the fort, with a heavy heart I reached the wharf, no one was left behind but many a heart clung to those sacred and battle scarred ramparts, I cannot describe my emotions. I felt as if every tie held dear to me was about to*

severed; the proud and glory of Sumter was there, and now in the gloom of darkness we were to abandon her, for whom every one of us would have shed the last drop of his blood.

As the Sumter garrison traveled up the Cooper River, they would have seen other forts vacant or retiring, such as Fort Johnson, Fort Ripley and Castle Pinckney. The fleet of Federal blockaders prevented any realistic chance of escape aboard their ships. They had but one option. The vessels the *Indian Chief*, the *Charleston*, the *Chicora*, the *Palmetto State* and the *Ravenel* were taken to the deepest parts of the harbor, set on fire and left to the mercy of the waves. Better they were destroyed than be used against them.

Huguenin's men disembarked, joining their brethren on the roads. The paths out of Charleston were choked with companies of Confederate soldiers, stripped down to the bare essentials, marching in silent unison. Horses were a rare commodity, reserved for the quartermaster's wagons and what artillery could be salvaged; nearly everyone was on foot, including the sailors, deprived of their ships, now serving as infantry. The Sumter garrison quickly fell into line, taking their place in the streaming mass.

If any turned for a last look, they would have seen Confederate Charleston's demise; fire and chaos served as the "Cradle of Secession's" death rattle. A chain reaction of explosions erupted along the wharves and within the city, casting out a thick blanket of smoke and noise. Fort Sumter was just the opposite. Its corpse lay quiet and still, reposing peacefully as the city it had long protected came apart.

Chapter 16

THE CHARLESTON DANCE CRAZE

In 1923, a new musical comedy titled *Runnin' Wild* opened on Broadway. Close to a dozen songs and numbers were featured in this production, but there was one by African American pianist and composer James P. Johnson that would go on to national fame and come to be regarded as a Roaring Twenties classic. According to tradition, Johnson penned the tune in 1923 with a group of transplanted South Carolinians who had found themselves employed in the New York waterfront district, in mind. Charleston's own Jenkins Orphanage band is sometimes credited with contributing to the creation of "The Charleston." In the early 1920s, the Jenkins Orphanage Band traveled the country, playing numerous fundraisers. One of the places they played their style of West African, Gullah rhythms was in Harlem. This sound had doubtless made an impression on the musicians of New York, as it soon found its way into some of their songs, "The Charleston" included.

"The Charleston" and the dance of the same name quickly outgrew its Broadway roots and was soon danced not just on stage by actors, but by flappers in jazz clubs and speakeasies all across America.

Back in the Holy City, the attitude toward this new fad was mixed. Some viewed it as a potential economic boom, putting the name of Charleston in the heads of thousands of potential tourists.

This photograph taken at the height of the dance's popularity shows Representative Thomas Sanders McMillan (of Charleston, appropriately enough) in front of the U.S. Capitol Building, while Miss Ruth Bennett and Miss Sylvia Clavins perform some of the signature moves of "The Charleston" while astride a railing. *Courtesy of Library of Congress.*

The more conservative set associated it with loose morals and illegal liquor (Prohibition still being in effect).

Even before "The Charleston" had hit the scene, jazz and all things associated with it had come under fire. In 1921, *Ladies' Home Journal* magazine published an article titled "The Jazz Path of Degradation" by a dance instructor named John R. McMahon:

> *Our Middle West is supposed to be a citadel of Americanism and righteousness. Yet a survey of its length and breadth shows that it is badly spotted with the moral smallpox known as jazz. Those moaning saxophones and the rest of the instruments with their broken jerky rhythm make a purely sensual appeal. They call out to the low and rowdy instinct. All of us dancing teachers know this to be a fact. We have seen the effect of jazz music on our youth. The American people will never be the same as they were before they learned the disgraceful art of the shimmy and*

Charleston during the Prohibition period had mixed feelings about the eponymous song. *Courtesy of Library of Congress.*

toddle. It is likely that the birth rate will be affected. The next generation will show certain physical consequences. There will be more weaklings and fewer stalwarts. The crop of human weeds will increase. Instead of real men and women, we may reasonably expect an augmented stock of lounge lizards and second-quality vamps. Jazz dancing is a worse evil than the saloon and scarlet vice. Abolish jazz music. Abolish the fox trot, one step, toddle, tango stock of lounge lizards and second-quality vamps or any form of dancing that permits the gentleman to walk directly in front of his partner. The road to hell is paved with Jazz steps!

One article did not provide enough venting for Mr. McMahon. He wrote another piece in 1921 titled "Back To Pre-War Morals," in which he declared, "If Beethoven should return to earth and witness the doings of a jazz orchestra, he would thank heaven for his deafness…All this music has a droning, jerky incoherence

Numerous musicians and performers put their own spin on "The Charleston." *From the collections of the SCHS.*

interrupted with a spasmodic blah! blah! blah! that reminded me of the way that live sheep are turned into mutton."

A local voiced a more progressive opinion in a letter to the editor: "For every hundred people who knew where Charleston was before this wonderful dance came out, there are ten thousand people asking where she is today." He urged his fellow Charlestonians to move into the modern era and realize the economic potential of this fad, rather than continuing to bank solely on the city's rich history and notable architecture. "After all, we can't eat iron gates." In the end, popularity seems to have swayed the city; in 1926 the Charleston Tourist and Convention Bureau held a local "Charleston" dance competition in conjunction with one in Chicago.

Other dances would soon come to eclipse "The Charleston," but few songs would leave such a lasting mark on America's cultural landscape. Perhaps the most apt summation of "The Charleston" phenomenon comes from music historian Leslie Stifelman: "The 'greatest hit' of 20th century popular music was not the creation of Michael Jackson, the Bee Gees or even the Beatles. Anyone with a sense of history will realize that the once-ubiquitous dance tune called the 'Charleston' fueled a craze that has never been matched."

Chapter 17

WILLIAM DEAS

Inventor of She-crab Soup

The following is a speech given by the author at a Southern Foodways Alliance Meeting in Charleston in June 2006:

Good morning. Thank you for allowing me a chance to speak about two of my favorite things: the history of Charleston and food.

Sadly, I can't say that I have ever had a chance to bring these two passions together before now. Unlike most of you, my primary field of interest in history is not on foodways, but in military history. But after seeing the itinerary for this conference and the restaurants you folks get to dine in, I must admit that I am seriously considering switching specialties. A stale bagel, cold coffee and a grain bar are considered good fare at most of the military history symposiums I have attended. So perhaps you will make a foodie out of me yet.

Focused as I was on bullets and battles, I stumbled over the story of William Deas and she-crab soup only through a chance assignment. While it may have begun by accident, my interest in this story has gone far beyond my original obligation, and become something of an ongoing research project.

Today I hope to outline the standard creation story of she-crab soup that appears in print, flesh out the identity and history of the man credited with perfecting the recipe, and discuss a popular myth surrounding its origin. There is no doubt in my mind that I still need to speak with more people, and still need to search in

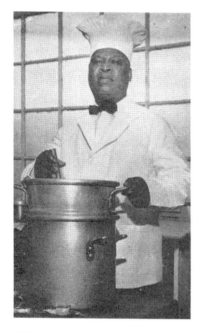

William Deas (1897–1961), World War I veteran and inventor of she-crab soup. *Courtesy of Everett Presson Jr.*

yet many more places, so what you will hear today is a work in progress rather than a polished finished product.

For close to two years I have been writing a small column for *charleston* magazine. The magazine often does theme issues, and the December 2006 edition featured Lowcountry cuisine. I panicked at this particular assignment; I knew nothing about the topic, and was sure that unless they let me do a write-up on hardtack, I was sunk.

Then I remembered a stray bit of trivia from the city of Charleston tour guide manual. To be a tour guide in Charleston you have to pass a written and oral exam based on a manual the size of a phonebook. I recalled that one of the questions on the exam had something to do with she-crab soup. I went back to the manual and reread the entry and rediscovered that she-crab soup was tied to the property at 116 Broad Street here in downtown Charleston.

An online search and a survey of the books on Charleston history offered little variation to the story published in the tour guide manual. To summarize, the basic story goes something like this: the house on Broad Street, now a bed-and-breakfast, had once belonged to Robert Goodwyn Rhett, a mayor of Charleston in the early 1900s. During Rhett's ownership, William Howard Taft, U.S. president and chief justice, visited Rhett many times as a weekend guest. During one of his visits, Mayor Rhett was concerned that the pale crab soup served to Taft was "too pale" and needed to be dressed up. Rhett's butler, a young African

American man named William Deas, rose to the occasion by adding the meat of the small female blue crabs and decorating the dish with their orange- hued eggs for a bit of color and extra taste.

Deas's culinary experiment was evidently a smashing success. Some accounts claim that Taft promptly added she-crab to the White House menu after returning to Washington. Others claimed that the Charleston well-to-do began ordering their own chefs to prepare some of that "William Deas Soup" or "Deas Soup," which eventually came to known as "she-crab soup."

Sadly, in many of the accounts Deas is not even mentioned by name, but simply as "the Rhetts' butler" or "the Rhetts' chef." The emphasis in these sources is rather placed upon Mayor Rhett for having the foresight to order someone else to dress up a dish, or on Mrs. Rhett, who later authored a cookbook. A couple of the better sources offered me the much-needed insight that she-crab soup had not developed in a vacuum, but rather was based on the Scottish seafood bisque partan bree brought to the New World by settlers in the early eigthteenth century.

While I was successful in finding more about the origin of the soup, not a single source I looked at mentioned anything about Deas's life before or after his moment of publicized inspiration at Mayor Rhett's house. I found it hard to believe that such a talented chef could simply fade into obscurity.

Luckily, I have the good fortune of working at an archive. A search of the South Carolina Historical Society pamphlet collection yielded one important find, a promotional piece for a Charleston restaurant called Everett's. This popular restaurant, which enjoyed its heyday in the 1950s and '60s, made a point of heavily advertising its star attraction, a chef by the name of William Deas. Apparently, the Rhett family moved out of their Broad Street home and out of the area in the 1920s. Deas stayed in the city and worked at several other homes and resorts as a chef and butler before enlisting the U.S. army during World War I. After the war, and back in Charleston, Deas met Everett Presson, who would be the namesake for Everett's restaurant.

The story of Everett's is an interesting one in its own right, and if you will bear with me, we will digress to discuss it momentarily

before circling back to Mr. Deas. This restaurant stood where the two-story Hardee's now stands on the Charleston Crosstown. Before the Crosstown that section of the city was the seat of a large African American community and African American–owned businesses. Yet Everett's was owned and operated by Everett Presson, a white entrepreneur. Mr. Presson did not come from a wealthy background, rather he had been a tenant farmer in North Carolina, and later operated a lunch stand on lower King Street across from where the Berlin's Department Store is today. He eventually was able to raise the capital to build Everett's just before World War II. Everett's is reputed to be the first building constructed specifically to be a restaurant in Charleston, but further work needs to be done to verify the accuracy of this claim.

Although it was built in a traditionally African American neighborhood and the wait and kitchen staff was predominately African American, it had white ownership and attracted an almost exclusive white clientele during the pre-segregation era in Charleston.

The race of the owners could certainly have been a factor, but it can also be argued that one of the reasons for this anomaly of patronage was the presence of Deas himself. Besides his name being attached to one of the city's signature dishes, he had worked for many years in service of Mayor Rhett's household, and after that in the posh resort Villa Margherita on South Battery overlooking Charleston Harbor, and in the homes of the other first families of Charleston.

While I can't pretend to know the hearts and minds of all those who frequented the restaurant, I don't think it is too much of stretch to say having Deas in the kitchen lent a certain cache to Everett's and was perhaps a comforting throwback to the circle of Charlestonians whose lifestyles were being changed as the civil rights movement gained momentum.

Mendel Rivers, a prominent congressman during the 1940s and through the cold war, was a frequent patron at Everett's and often held business meetings inside the restaurant. As head of numerous committees, Rivers would arrange to fly up thermoses filled with

she-crab soup prepared at Everetts' by Deas from Charleston to Washington, D.C., to feed attendees of these political meetings. Ironically, Rivers was a conservative Democrat and called the 1954 *Brown v. Board of Education* "unconstitutional and immoral" and asserted that the NAACP was under communist influence.

While Everett Presson, the namesake of this restaurant, had passed away in the early 1970s, I did manage to locate Everett Presson Jr., still in the area. The restaurant had been very much a family business and Presson spent his youth working in Everett's. It was Presson who told me of Mendel Rivers's consistent patronage and his special arrangements regarding she-crab soup.

Presson was able to add a much more human element to my *charleston* magazine article. He told me how Deas and his wife were well versed in the nuances of polite society, and made the remark that everything he learned about manners he learned from them. He also told me that neither he nor his father, Mr. Presson Sr., had been much of a cook, and that Mr. Deas had done much of the work managing the kitchen and its staff. When Mr. Deas became too infirm for such a rigorous job, he switched to waiting tables. His memory wasn't so good at this point in his life, but he compensated with his sense of humor; if he got someone's order wrong, he would convince them what he brought was better than what they had asked for anyway. Presson also vividly recalled that in over twenty years of employment, Deas never missed a day of work for any reason.

During my interview with Presson, he showed me documentation that his father had a dining room in the restaurant named the Deas Room in the honor of his star chef. This would be the first time any such area carried the name of a black chef in Charleston.

As to Deas's famous dish, it was advertised on the menu and the recipe was given away freely. Presson noted that "it was the original and the best. It was full of crab meat, not too thick, and the roe gave it a special flavor." He also remarked that while many have the recipe, no one has been able to exactly duplicate Deas's creation. No one, even today, has managed to get it exactly right, he claimed.

I also obtained some new leads from Presson that enabled me to track down Alonzo Deas, son of William Deas, a World War II veteran living on nearby James Island. Alonzo Deas told me many more stories, including how his father had an exquisite voice and used to sing gospel music while at work in the kitchen or serving tables as a waiter.

Through my discussions with Alonzo Deas and Presson I have formed the opinion that the celebrated story of President Taft is likely apocryphal. When I asked Alonzo Deas if his father had ever spoken of the famous incident involving President Taft, he said that he could not recall Deas Sr. having mentioned it. Everett Presson Jr. said in the decade and a half of working alongside William Deas, he could not recall him ever mentioning Taft. This seems an odd omission, and lends credence to the theory that perhaps the story was a PR device cobbled together from unconnected facts.

There is no doubt that William Deas perfected the recipe for she-crab soup. Too many of Deas's contemporaries corroborate this fact for it to be suspect. There is also no doubt that President Taft and First Lady Nellie Taft frequented Charleston and dined while there. Their visits were social occasions remarked upon by the newspapers of the day.

Nellie Taft, for instance, complained that Southerners were "strange" for their annoying habit of "always taking an half hour to get ready for everything." She also remarked in a letter that she got "tired of eating chicken all the time, but that's the way Charleston people live."

Yet how many of us, after having their name linked to that of a president, never mention it? I know if it were me, I would annoy friends and family with this tale at every possible occasion. Yet Deas never mentioned it to his son or to Presson who had spent over a decade alongside him at Everett's.

My intention at debunking this bit of popular mythology is not to discredit Deas or his contribution, but rather to take the limelight off of Taft and Rhett and shine it on the man himself.

At 6:40 p.m. on June 16, 1961, William Deas died of a stroke at the U.S. Naval Hospital. The next day two obituary notices ran in

President Taft, who often visited Charleston and was known for his love of the table, is often associated with the origin of she-crab soup. *Courtesy of Library of Congress.*

the *News and Courier* paper with the headline "William Deas" and "William Deas, inventor of she crab soup, dies at 64." Of course, Mayor Rhett was given billing in these notices as well, and one of the notices claimed that he had simply learned the recipe while in service to the Rhetts, subtly intimating that Mrs. Rhett had actually been the one who had developed it.

On the day of the funeral Everett's closed in the middle of the day for three hours so that its staff could attend the services.

Everett's would go on in fits and starts, and eventually closed in the 1970s. It was demolished and replaced by the two-story fast-food restaurant Hardee's. If it does turn out that Everett's was in fact the first building constructed as a restaurant in Charleston, this will be a black mark of shame on our preservation efforts in this city. Presson Jr. would go into real estate, and is still today a successful agent for Prudential. The Deas family would also retire from the restaurant business.

The dish of she-crab soup, however, would never retire, and only gained popularity. Today, perhaps only shrimp and grits appear more often on the menus of Charleston's restaurants than she-crab soup. According to food historian Dan Huntley, she-crab soup helped put Charleston on the regional culinary road map as surely as Philadelphia's cheese steaks or Chicago's deep-dish pizza did the same for those locations.

My magazine article was finished months ago, but the story has never been far from my mind. My wife nearly died of shock when I announced that I planned to spearhead the effort to get she-crab soup named South Carolina's state soup. She noted with some amazement, "but it has nothing to do with a battlefield."

So if you want to join me in this crusade, I welcome your expert opinion and advice on how I can accomplish this. But for today, as you explore Charleston's cuisine, I leave it to you to prove Nellie Taft wrong. Don't take a half hour to get to the restaurant, and when you do, don't simply order the chicken. Demand a bowl of some of that William Deas soup.

Thank you.

SELECTED BIBLIOGRAPHY

Archer, Stephen M. *Junius Brutus Booth: Theatrical Prometheus*. Carbondale: Southern Illinois University, 1992.

Bowden, David K. *The Execution of Isaac Hayne*. Lexington, SC: Sandlapper Store, Inc., 1977.

Browning, Robert M., Jr. *Success is All That Was Expected*. Washington, D.C.: Brassey Inc., 2002.

Burton, E. Milby. *The Siege of Charleston, 1861–1865*. Columbia: University of South Carolina Press, 1970.

Butler, Dr. Nicholas. "300th Anniversary of Spanish-French Invasion." CCPL. Charleston County Library, Charleston, SC. August 6, 2006.

Calhoun Vertical Files. Ms. 30-4. South Carolina Historical Society, Charleston.

Campbell, R.T., ed. *Engineer in Gray*. Jefferson, NC: McFarland & Co., 2005.

———. *Hunters of the Night*. Shippensburg, PA: Burd St. Press, 2000.

Caroline Howard Gilman Papers, 1810–1880. Ms. 1036.00. South Carolina Historical Society, Charleston.

Carson, James Petigru. *Life, Letters and Speeches of James Louis Petigru: The Union Man of South Carolina*. Washington, D.C.: W.H. Lowdermilk, 1920.

Charles Kuhn Prioleau Correspondence, 1860–1865. Ms. 1280.00. South Carolina Historical Society, Charleston.

Coker, P.C. *Charleston's Maritime Heritage 1670–1865*. Charleston, SC: CokerCraft Press, 1987.

Colcock, John. Case of Colonel Hayne, 1781. Ms. 43-0083. South Carolina Historical Society, Charleston, 1781.

Detzer, David. *Allegiance*. New York: Harcourt, Inc., 2001.

Douglass Family Papers, 1860–1912. Ms. 0118.03.03. South Carolina Historical Society, Charleston.

Duke, Seymour R. *Osceola or Fact and Fiction*. New York: Harper & Brothers, 1838.

Edgar, Walter. *South Carolina: A History*. Columbia: University of South Carolina Press, 1998.

————, ed. *The South Carolina Encyclopedia*. Columbia: University of South Carolina Press, 2006.

Fraser, Walter J., Jr. *Charleston! Charleston!* Columbia: University of South Carolina Press, 1989.

Hayne, R.Y. "Biographical Memoir of David Ramsay, M.D." *Analectic Magazine*, September 1815.

Hayne Vertical Files. Ms. 30-4. South Carolina Historical Society, Charleston.

Hubert, Julie. "The Orphange." Symposia "Jenkins Orphanage," University of South Carolina, winter 2007. http://www.sc.edu/orphanfilm/orphange/symposia/scholarship/hubbert/jenkins-orphange.html.

Hutson, Charles W. My Reminiscences. Ms. 43/2218. South Carolina Historical Society, Charleston, 1925.

Johnson, John. *Defense of Charleston Harbor Including Fort Sumter and the Adjacent Islands 1863–1865*. Charleston, SC: Walker, Evans & Cogswell Co., 1890.

Mahon, John K. *History of the Second Seminole War, 1835–1842*. Gainesville: University of Florida Press, 1990.

Marion Vertical Files. Ms. 30-4. South Carolina Historical Society, Charleston.

May, John Amasa, and Joan Reynolds Faunt. *South Carolina Secedes: "…to Dissolve the Union Between the State of South Carolina and Other States…"* Columbia: South Carolina Confederate War Centennial Commission, 1960.

Middleton, Margaret Simons. *David and Martha Laurens Ramsay*. New York: Carlton Press, 1971.

Mustard, Harry S. Harry S. Mustard Research Papers. Ms. 0149.00. South Carolina Historical Society, Charleston.

Obituary Addresses Delivered on the Occasion of the Death of Honorable John C. Calhoun. Washington, D.C.: Senate of the United States, 1850.

O'Kelly, Patrick. *Nothing But Blood and Slaughter: Volume One*. Lillington, NC: Blue House Tavern Press, 2004.

————. *Nothing But Blood and Slaughter: Volume Three*. Lillington, NC: Blue House Tavern Press, 2005.

Osceola Vertical File. Ms. 30-4. South Carolina Historical Society, Charleston.

Presson, Everett, Jr. Personal interview, April–May 2007.

Pyatt, Sherman. Personal interview, April–May 2007.

Ramsay, David. *The History of the Revolution of South-Carolina, From a British Province to an Independent State*. Trenton, NJ: Isaac Collins, 1785.

————. *Ramsay's History of South Carolina From Its First Settlement in 1670 to the Year 1808, Volume I*. Newberry, SC: W.J. Duffie, 1858.

————. *Ramsay's History of South Carolina From Its First Settlement in 1670 to the Year 1808, Volume II*. Newberry, SC: W.J. Duffie, 1858.

Reminiscences of Charleston in 1860. Ms. 43/1001. South Carolina Historical Society, Charleston.

Rosen, Robert. *Confederate Charleston*. Columbia: University of South Carolina Press, 1994.

Russell, David L. *Victory on Sullivan's Island*. West Conshohocken, PA: Infinity, 2002.

Salley, A.S., comp. *Records in the British Public Record Office Relating to South Carolina 1701–1710*. Columbia, SC: Crowson-Stone, 1947.

Smith, Gene. *American Gothic: The Story of America's Legendary Theatrical Family—Junius, Edwin, and John Wilkes Booth*. New York: Simon & Schuster, 1992.

Smith, Mark M. *Stono: Documenting and Interpreting a Southern Slave Revolt*. Columbia: University of South Carolina Press, 2005.

South Carolina Gazette Vertical File. Ms. 30-12-53. South Carolina Historical Society, Charleston.

Stifelman, Lesile. "James P. Johnson: A Composer Rescued." *Columbia Journal of American Studies* 1 (1995). http://www.cjasmonthly.com/archives/vol1num1/page8.pdf.

Stokely, Jim. *Fort Moultrie, Constant Defender*. Washington, D.C.: National Park Service, 1986.

Stoney, Augustine T. Stoney Papers (Augustine Thomas Smythe). Ms. 1209.02.02. South Carolina Historical Society, Charleston.

Timothy Family Vertical File. Ms. 30-4. South Carolina Historical Society, Charleston.

Tomb, James H. Memoirs of James H. Tomb. Tower Room Collection Rare PAM. South Carolina Historical Society, Charleston.

Voices of the Civil War—Charleston. Alexandria, VA: Time-Life Books, 1997.

Wallace, David. *South Carolina a Short History 1520–1948*. Chapel Hill: University of North Carolina Press, 1951.

Weeks, Carnes. "David Ramsay: Physician, Patriot and Historian." *Annals of Medical History* 1929.

Wickman, Patricia R. *Osceola's Legacy*. Tuscaloosa: University of Alabama Press, 1991.

Wilcox, Arthur M., and Warren Ripley. *The Civil War at Charleston*. 21st ed. Charleston, SC: Post and Courier, 2000.

William Thomson Vertical File. Ms. 30-4. South Carolina Historical Society, Charleston.

Wood, Peter H. *Black Majority: Negroes in Colonial South Carolina From 1670 Through the Stono Rebellion*. New York: W.W. Norton & Company, 1996.

Yuhl, Stephanie Eileen. *A Golden Haze of Memory: The Making of Charleston*. Chapel Hill: University of North Carolina Press, 2005.

Visit us at
www.historypress.net